Birds

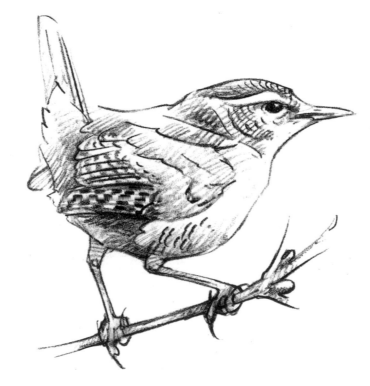

PETER PARTINGTON

First published in 1998 by
HarperCollins*Publishers*
1 London Bridge Street
London
SE1 9GF

Collins is a registered trademark of
HarperCollins Publishers Limited

The HarperCollins website address is
www.**fire**and**water**.com

16 18 20 19 17 15
6 8 10 9 7

Produced by Kingfisher Design, London
Editor: Diana Craig
Art Director: Pedro Prá-Lopez
Designer: Frances Prá-Lopez

Contributing artists:
David Bennett *(page 53 bottom)*
John Busby *(pages 48 centre left, 50, 51, 52 groups top and right)*
John Davis *(pages 40, 41, 64)*
Robert Greenhalf *(page 52 group left)*
Andrew Haslen *(page 48 centre right, 61 top)*
Martin Hayward Harris *(pages 34, 35 top left, bottom left and right, 36, 37, 38, 39)*

A catalogue record for this book is available from the British Library

ISBN 978 0 00 413351 5

Printed and bound in China by
RR Donnelley APS

CONTENTS

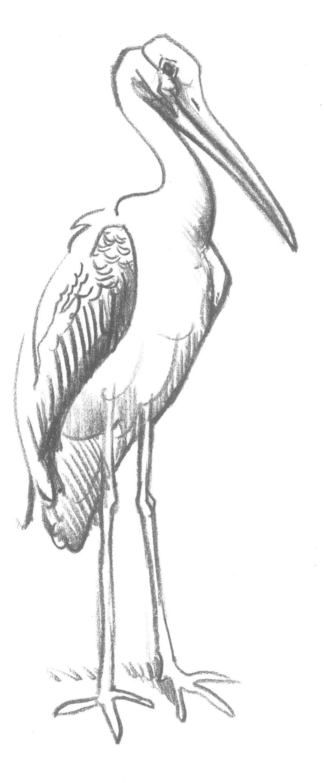

Introduction

The beauty and diversity of birds is a wonderful incentive for drawing. If you choose to draw birds, you will never be short of subject matter, for the excitement and wealth of bird-life is all around us – the sparrow on the roof; doves and thrushes in the garden; kestrels in the woods; water birds on our shores; and eagles in the wilderness. Visual miracles such as a blackbird sunning itself, its wings spread in the flowerbed, or a great tit upside down on the feeder are there if you have eyes to see them.

These days, our knowledge of birds is greater than ever before, even if our technology is threatening their survival at the same time. We know now about their heroic migrations, their struggles for territory, their often bizarre displays to attract a mate and perpetuate their species. The fragile beauty of the blue tit contrasts with its fierce urge to live. The soaring eagle still has to contend with finding food and the vagaries of weather.

Finding ways to express ourselves through drawing birds in all the various media is another delightful journey of exploration. It is also an excuse, if one was needed, to pass happy days outside observing your subject matter. Your sketchbooks will record birds in all habitats, in all weathers and light conditions. You will find yourself looking at birds more closely and visiting wonderful places.

When you are studying birds, try to keep a low profile and approach them quietly. Telescopes and binoculars give us great advantages, allowing us to watch from a distance. There are also a multitude of bird reserves where there are hides from which to observe unseen. Avoid birds on the nest in case you disturb them and cause them to desert. You must get a permit from the Nature Conservancy Council to draw,

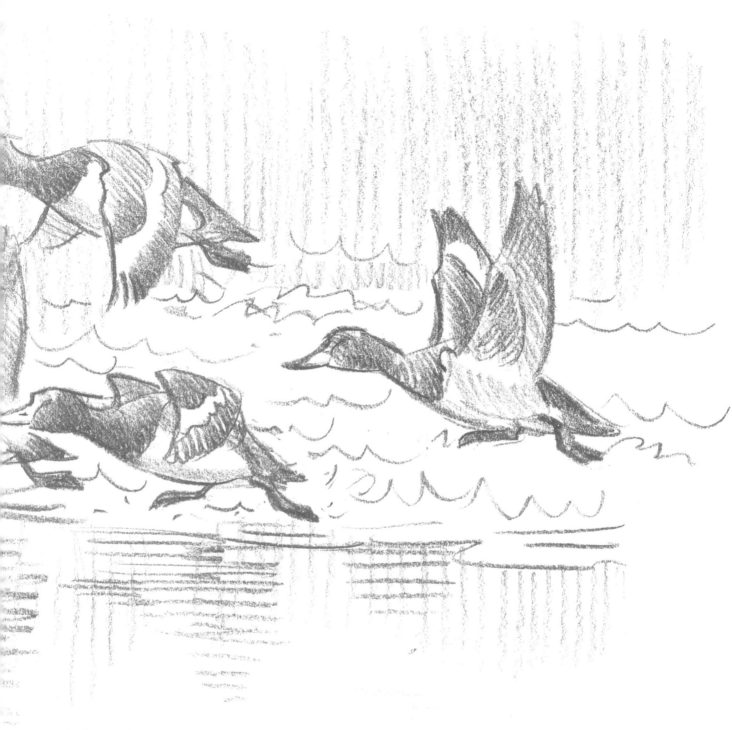

photograph or even approach many of the
species on the nest itself. Any questions you
have can be answered by the Royal Society for
the Protection of Birds at The Lodge, Sandy,
Bedfordshire SG19 2DL.

Good drawing!

Tools and Equipment

Any medium can be used to capture the diversity that bird-life presents to us, but each tool does create a slightly different effect and mood, so some may be better suited than others for conveying the impression of a particular subject. For the beginner, the huge range of drawing materials available may seem daunting, but don't let this deter you – excitement and enjoyment in trying them all awaits you.

Pencils

Capable of producing rough, quick sketches as well as finely worked detail, the everyday pencil is one of the most versatile of drawing instruments. Pencils come in various degrees of hardness and it is this that affects the quality of line. The H range, ending with the super hard 9H, creates a light, precise line ideal for careful studies of eyes and feathers. The soft B range,

culminating in the luxurious 9B, can provide rich, rough, textural effects and striking tonal variations. Midway between the hardness of the H range and the softness of the B range is the well-known HB all-rounder.

Specialized pencils such as clutch and propelling pencils are preferred by some. These produce a continuous and consistent line and do not need to be constantly sharpened, but they come in a lower range of softness. Watercolour pencils produce a line which can be softened with a wash of water. Colour pencils enable you to draw and introduce colour simultaneously.

Explore the range of pencils by using as many different types as possible and discover what effects they produce and which suits your intention and feelings best.

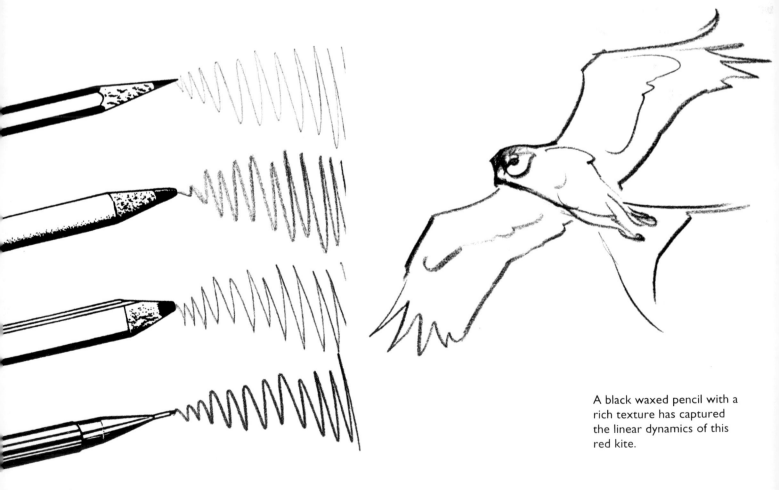

A black waxed pencil with a rich texture has captured the linear dynamics of this red kite.

I used a ballpoint pen for this sketch of a jay. The fine lines created by this type of pen enabled me to work into the bird with great fineness, and its speed meant that I could cross-hatch quickly (use criss-crossing lines) to create depth of tone as well.

Pens

Pens can produce a fluid, uncompromising line, and are available in several varieties suited to different uses and producing different effects.

Fountain and **dip pens** allow the artist to draw free-flowing or angular lines which vary in thickness depending upon the pressure applied.

Ballpoint and **technical pens** produce a consistent fine line. Their speed of application makes them useful for sketching moving birds.

Felt-tip pens

Felt-tips have nibs in a range of thicknesses, ranging from finely pointed to wide and blunt-ended, and produce marks accordingly.

Felt-tip pen enabled me to capture the flowing plumage pattern of this quail. I drew in a faint pencil outline first to serve as a guide for the penwork.

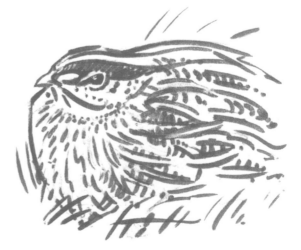

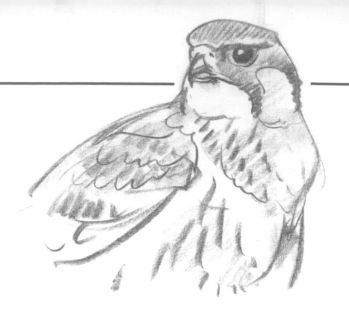

The rough surface quality of conté pencil gives this sketch a good textural feeling. This Saker falcon was found at a local falconry centre.

Pastels, chalks and crayons

These work best on rough papers. The rich powdery marks and lines which they produce can be smudged and blended with a clean finger. They are ideal for conveying the depth of thick feathers or the sheen on a glossy wing because you can work light over dark or allow the coloured paper base to show through.

Pastels and **chalks** are particularly effective for lively, spontaneous drawing, and their soft, textural quality offers an exciting alternative to the precision of pencils and pens. They can be used on their tips, or on their sides to fill large areas quickly. Their rough, unfocused line can suggest light, movement and mood.

Conté crayon has a slightly greasy texture and is less crumbly but similar in quality to pastel.

Oil pastels and **wax crayons** allow you to introduce colour at the same time as line and contour, and come in a dazzling array of colours. Take care not to over-work wax crayon; soft oil pastels can be built up to resemble oil paint. These 'greasy' media are difficult to erase so plan your picture carefully before you begin.

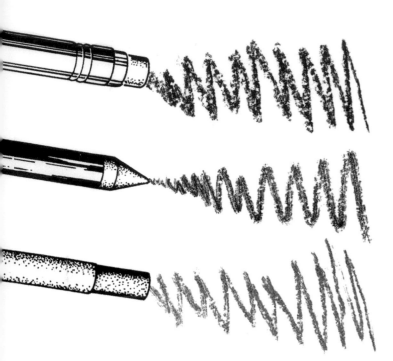

Charcoal pencil gave me the depth of tone I needed for the black stripe down the centre of the great tit's chest.

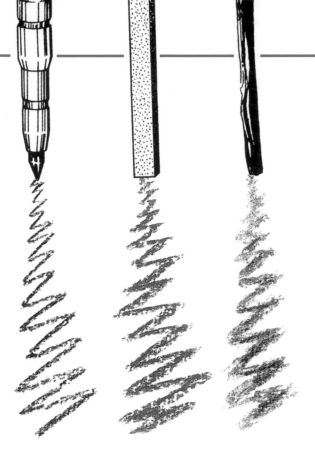

Charcoal

This is perfect for working on a large scale. It comes in stick form but its luxurious softness can be rather messy and drawings using this medium can easily become overworked. For ease of handling, charcoal is also made in compressed pencil form. This produces a similar effect to the non-compressed variety but is more manageable if you wish to do smaller-scale work. To achieve a fine line with charcoal, gently rub the tip of the stick to produce a point. To create highlights in a charcoal (or pastel) drawing, lift them out by dabbing with a putty eraser.

Compressed graphite sticks

These look like large pencil 'leads'. They come in various softnesses, and produce effects that resemble generous pencil strokes. They are a good tool to use if you want to work quickly, building up your drawing with a large number of hatched lines (series of fine lines).

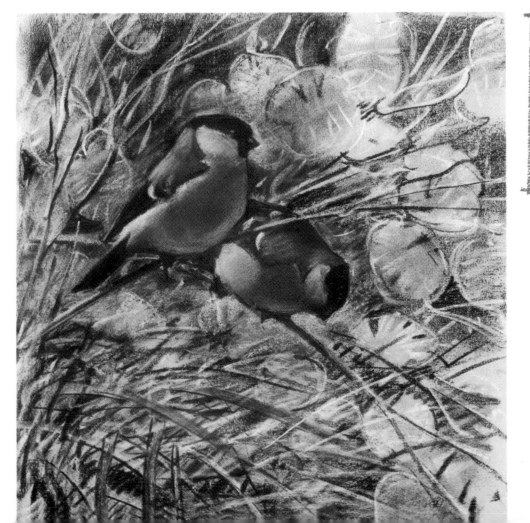

I used pastel on a mid-grey paper to bring out the image of the two bullfinches and the seed-heads on which they feed.

Artist's Tip

While working with these delicate media, rest your hand on a piece of paper to protect completed areas from smudging, and cover them when you take a break.

Brushes and wet media

As well as being used for drawing the lines that define form and outline, certain wet media such as watercolour can be used to add colour or tone to a drawing. The type of line you make with wet media is determined by the brush used.

Brushes have tips that come in a wide range of shapes and lengths. Brushes with flat tips, either short, long or wide, are the best type for covering large areas or for producing extreme variations of line in a similar way to a calligraphic pen. Among the most useful brushes for drawing are those that have long pointed tips, the 'rigger' type being the longest. These produce extended, fine lines. However, the length of these tips makes them very pliable and they can be hard to control. Brushes with short-tipped points are more manageable and can be used for fine detail.

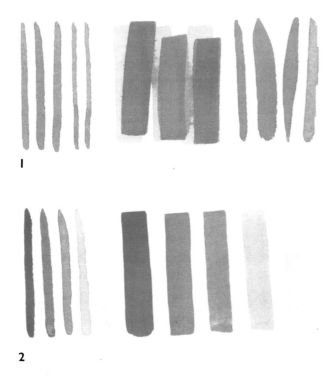

1 These marks were made with *(from left to right)* a small round No 2 brush, a ⅜in flat chisel brush, and a large round No 12 brush.

2 Watercolour tone can be made progressively lighter by adding more water, as shown by these strokes using different dilutions.

3

5

4

6

3 For an even layer of strong watercolour, add darker washes to a light wash while still wet.

4 To prevent colours 'bleeding' together, allow the first layer to dry before you add the next.

5 For a soft blurry effect, apply watercolour to paper that has been slightly dampened.

6 Ink or concentrated watercolour on damp paper will 'flare' and spread into the wash.

The fibres or hairs used for brush tips vary in quality. Sable brushes are the best quality and give very attractive results, but they are expensive. Cheaper squirrel and synthetic fibres are quite adequate, however, and produce good-quality work.

The tensile springiness of synthetic fibres can create fine dynamic lines that are ideal for expressing the liveliness of birds. Brush pens are good for this, too; they come supplied with a cartridge of coloured ink which ensures a consistent flow of colour.

Watercolour produces transparent tones and gentle washes when diluted. For stronger, more vivid colours, reduce the amount of dilution. Use brush or dip pen for applying watercolour.

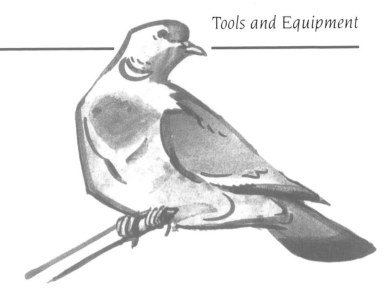

Gouache is a form of watercolour containing a good deal of white and offers bold, opaque colour and dense coverage.

Acrylic paint can resemble oil paint when used thickly. It can be diluted with water to achieve a watercolour effect.

Ink may be waterproof or not, and may be applied with a pen to produce a line drawing or diluted and brushed on as a wash. The two methods may be combined in a line-and-wash drawing.

A fine brush drew the wood pigeon's outline and transparent washes filled in tone and form.

For wet media you will need a palette for mixing and a couple of jam jars, one containing water for mixing your colours, the other for washing your brushes.

Indian ink on a fine brush enabled me to get this bold drawing of a long-eared owl down quickly. I diluted the ink to add tone and texture to the feathers.

Artist's Tip

Do not forget to wash out your brushes if you are using waterproof ink. It will harden on the brush and is extremely difficult to clean out.

11

Newsprint is very inexpensive, which makes it good for practising and rough sketching.

Tracing paper is semi-transparent, so that you can lay it over other images and trace them.

Stationery paper, usually available in standard sizes, has a smooth surface which works well with pen.

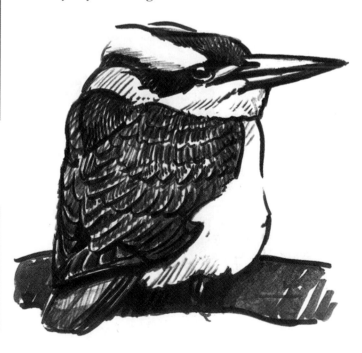

Cartridge paper has a slightly textured surface, and is one of the most versatile surfaces.

Surfaces to draw on

It is exciting to explore the way in which different surfaces change the appearance of a particular medium. With experience, you will gradually learn which suits your style best and which suits the medium you are working with.

Watercolour paper is tough and absorbent, consisting partly or wholly of cotton and linen fibres which can give it an almost blotting-paper-like quality. It will withstand rigorous drawing and watercolour washes, and is acid-free so it will not go brown if left in the daylight. It is the most expensive paper you can buy and may be made by hand or machine. It comes in different thicknesses that are measured according to the weight of a square metre. It often has an attractive texture – 'laid' or 'wove' – according to the mould in which it is made.

Cartridge paper can be bought in rolls or sheets and may be either cream or white. It is the most versatile and inexpensive all-round surface for everyday drawing.

This kookaburra posed for me in a bird park. I brought the drawings back to my studio and rendered this one in felt-tip pen on cartridge paper.

Pastel and Ingres papers, in many colours with textured surfaces, are ideal for pastel, charcoal and conté.

Watercolour paper is absorbent, and can have a rough or smooth surface. It is ideal for wet media.

Bristol board has a smooth surface which makes it highly suitable for drawings in pen and ink.

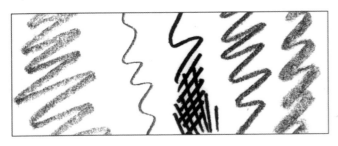

Layout paper is a semi-opaque, lightweight paper which is suitable for both pen and pencil.

Cheap papers are another alternative. For example, the matt side of brown wrapping paper makes an interesting surface on which to work, as does photocopy paper and plain newspaper.

Blocks, books and **pads** are useful for outdoor sketching. Blocks are made of ready-cut and stretched watercolour paper on a card base. Books consist of watercolour and cartridge paper with a hard back. Pads are usually made of cartridge paper, spiral-bound or glued. They are available in two formats, portrait or upright and landscape or horizontal.

Paper has three grades of surface: *hot-pressed*, or HP (smooth); NOT (not hot-pressed); and *rough* which is more textured.

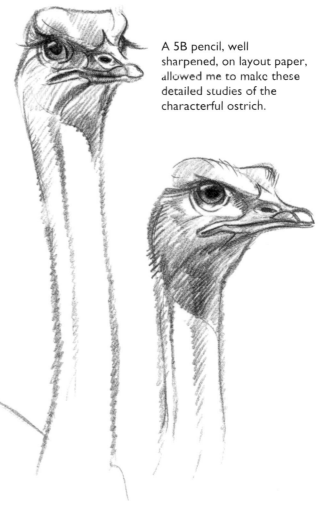

A 5B pencil, well sharpened, on layout paper, allowed me to make these detailed studies of the characterful ostrich.

Choosing the Right Medium

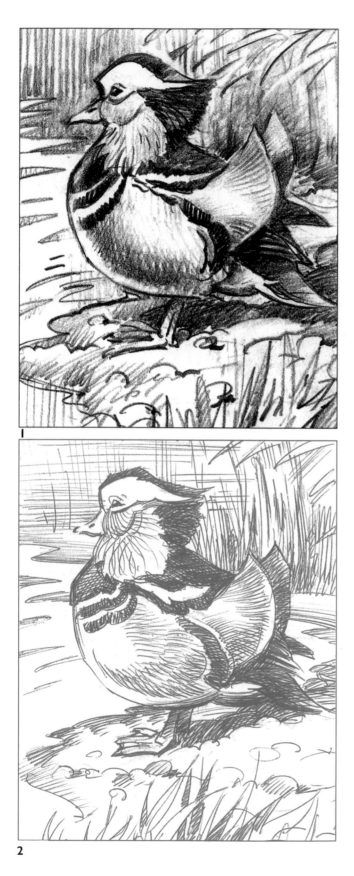

1

2

A world of exploration awaits you as you discover the possibilities offered by all the media available to the artist. Each medium has its own character, and you may find that one in particular suits you best. You may, for example, discover that you derive intense enjoyment from the wet-in-wet techniques of brushwork on damp watercolour paper, or you may simply enjoy adding watercolour to your pencil sketches that you have transferred from your sketchbook. As you practise, you will find that you will improve your handling of line, colour, tone and texture.

The surfaces to which you apply your techniques offer varied results as well. Soft pencil on cartridge paper will give you a quick, firm response for sketching and you can rub and blend in with your finger to create softer effects. The pencil work can be easily erased to reclaim lost highlights. By contrast, ballpoint pen on white card allows for crisp, fine detail similar to that of an engraving. A brushful of Indian ink, strong or diluted, on dampened watercolour paper will give you an engagingly sensuous effect. A slightly rough surface will suit the discipline brought by a crisp pen-and-ink over-drawing to watercolour. Rough paper and a charcoal stick, used on its side as well as its end, gives a wide range of warm, black tones and a quick rendition of light and shade.

As you can see, these drawings of a mandarin duck are virtually identical, but the effect of different combinations of media and surfaces gives each one a very different quality.

I Soft pencil on writing paper
2 Ballpoint pen on white card
3 Watercolour washes on 300gm²/140lb NOT surface watercolour paper
4 Watercolour wash and dip-pen on 300gm²/140lb

HP (smooth) watercolour paper
5 Brush and Indian ink on dampened watercolour paper
6 Charcoal stick on textured notepaper

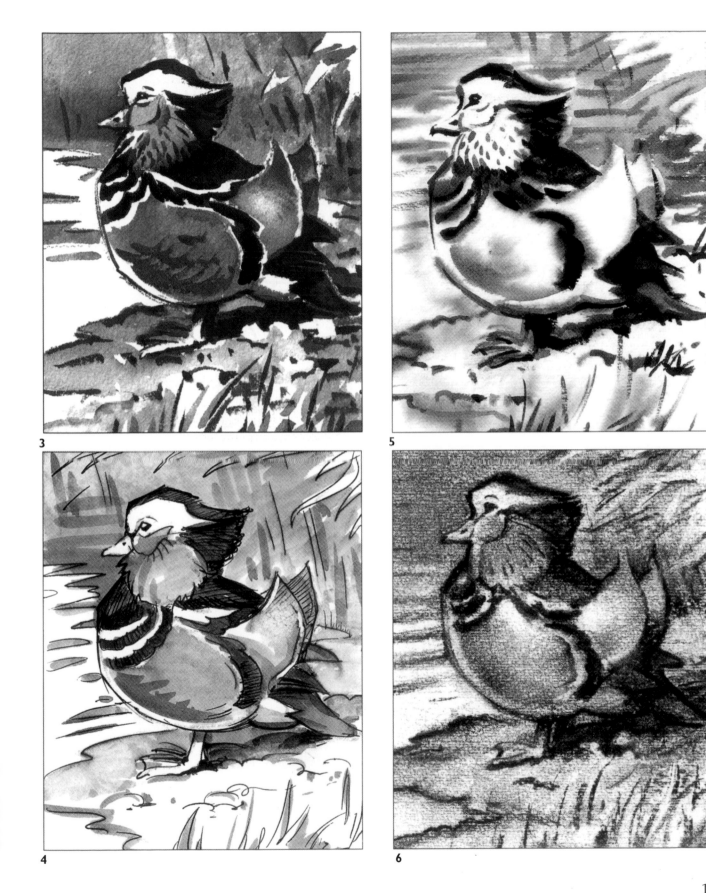

3

5

4

6

Basic Shapes

The successful approach to drawing birds begins with visualizing the basic shapes that lie behind even the most complex appearances. A basic tear-drop shape, with some variations, is common to most birds.

Kingfisher, woodpecker and finch
One of the simplest birds to begin with is the kingfisher. Its tail is short and pointed and you can rarely see its small legs, so what you are left with is a tear-drop body shape.

In the case of the woodpecker, the bird's head is relatively smaller and the tail – which it uses for resting on the tree trunks it climbs – is longer and spikier. The tail should flow out from the basic body shape.

In the finches, the basic tear-drop is even more pronounced. In the drawing opposite the bird is standing on the ground, so the tear-drop is angled horizontally. The neck is short and the head tends to rest back on the body.

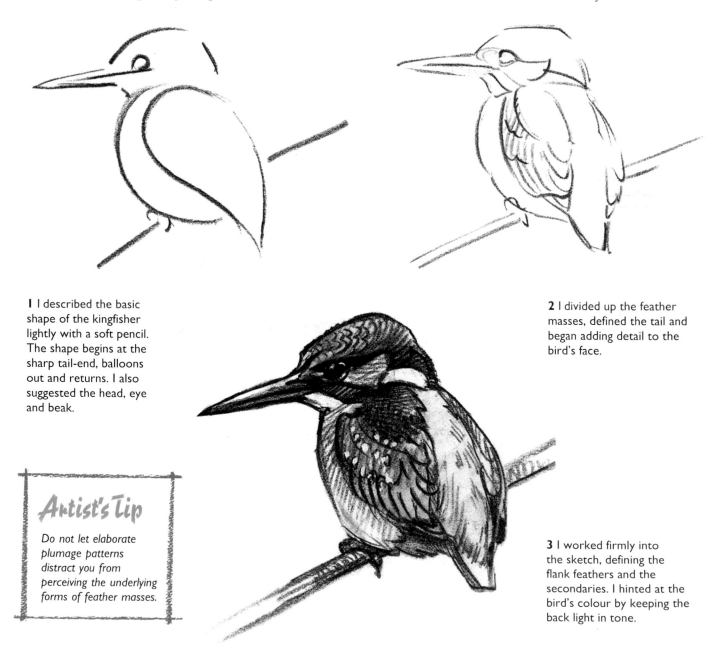

1 I described the basic shape of the kingfisher lightly with a soft pencil. The shape begins at the sharp tail-end, balloons out and returns. I also suggested the head, eye and beak.

2 I divided up the feather masses, defined the tail and began adding detail to the bird's face.

3 I worked firmly into the sketch, defining the flank feathers and the secondaries. I hinted at the bird's colour by keeping the back light in tone.

Artist's Tip

Do not let elaborate plumage patterns distract you from perceiving the underlying forms of feather masses.

1 I drew in the tear-drop shape of this woodpecker, following the angle of the tree trunk. I situated the head and marked in the bill and eye.

2 I divided up the plumage areas into their parts, and defined the clinging toes.

3 I used hatching to suggest contour and tone on the bird's head and back, and left a spot in the eye for the highlight.

1 I quickly sketched in the basic shapes of these finches, noting that the bird behind is more circular.

2 I described the shapes and patterns of the plumage, allowing them to flow around the form.

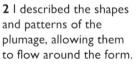

Owls

With their sculptural shapes, big eyes and cat-like expressions, owls are extremely attractive to draw. The three shown here are very common. The little owl sits on telegraph poles and swoops on its prey. The tawny owl frequents woodland, so bear this in mind when you are adding backgrounds. The barn owl hunts across rough pastures and can sometimes be seen by day if it is putting in overtime feeding a family.

The little owl is squat in shape. It has well-defined eyebrows which give its head a more rectangular character. The facial discs of the barn owl can be seen as a heart-shape divided down the middle.

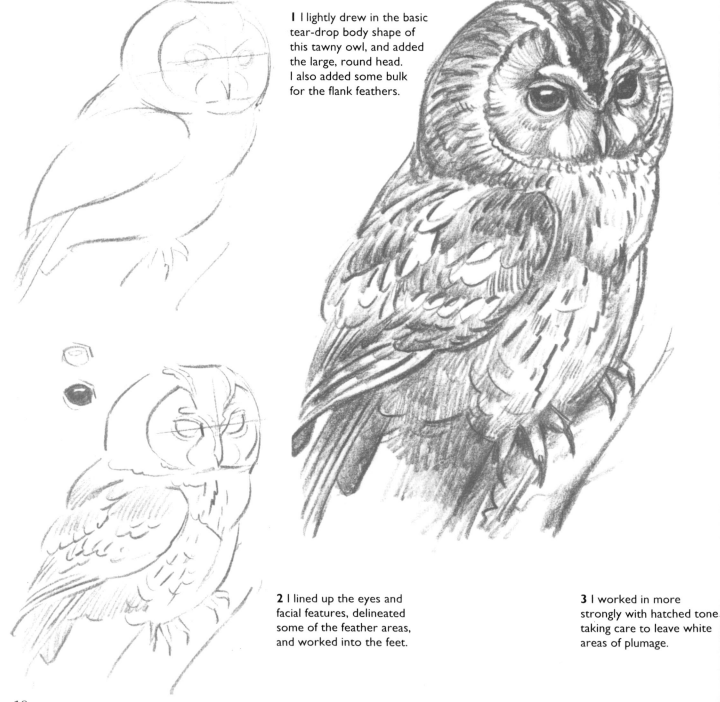

1 I lightly drew in the basic tear-drop body shape of this tawny owl, and added the large, round head. I also added some bulk for the flank feathers.

2 I lined up the eyes and facial features, delineated some of the feather areas, and worked into the feet.

3 I worked in more strongly with hatched tone taking care to leave white areas of plumage.

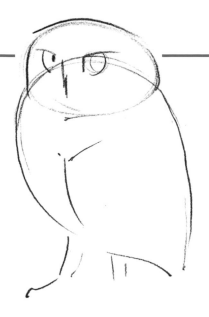
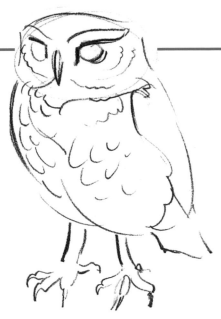
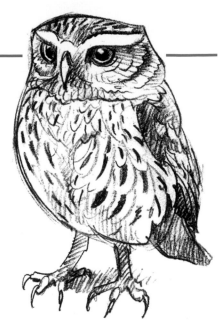

1 I marked in the basic shapes of this little owl, setting the head well into the body.

2 Working into the preliminary sketch, I suggested feather surfaces and stressed the strong feet.

3 I worked in details of the striations on individual feathers, and completed the bright eyes with their black pupils, leaving patches of white for highlights.

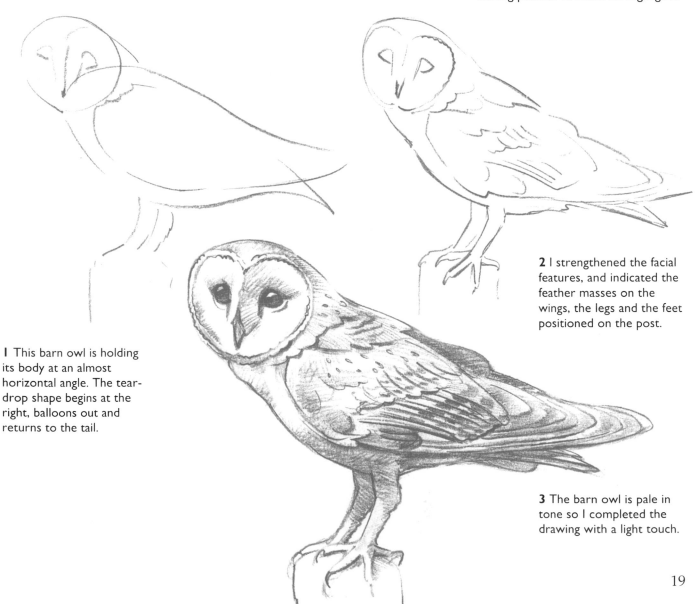

1 This barn owl is holding its body at an almost horizontal angle. The teardrop shape begins at the right, balloons out and returns to the tail.

2 I strengthened the facial features, and indicated the feather masses on the wings, the legs and the feet positioned on the post.

3 The barn owl is pale in tone so I completed the drawing with a light touch.

Ducks, geese and swans

Ducks, geese and swans have spoon-like bills, webbed feet and compact waterproof plumage. Because they often undertake long and seasonal migratory journeys, they are muscular as well as streamlined, and their wing muscles give them a full-breasted effect. They are seed- and plant-eaters so they often have a full crop at the front which emphasizes their forward momentum.

The teal is one of the smallest ducks, which you can tell from the relative size of its head – the smaller the bird, the bigger the head in relation to the body. To check this, look at the swan, whose comparatively small head implies a large body. The pintail is a bigger duck than the teal; its neck is longer and it holds its head higher.

In terms of shape and size, geese provide a bridge between the ducks and swans. Again, see how the relative head size of the goose suggests the bird's proportions.

When drawing the teal *(above)*, use the basic tear-drop shape but emphasize its roundness. Note how the teal's head tucks into its body.

Add a sharp tail to the pintail's basic tear-drop and place the head a bit higher than that of the teal *(above)*.

The swan's long neck is a separate addition to the main body shape *(left)*.

Artist's Tip

If you draw in the local park, attract ducks with a handful of grain. Capture movement with a squiggle that can be improved upon later.

The Canada goose has distinct plumage areas, so use these to give your drawing a sense of roundness *(left)*.

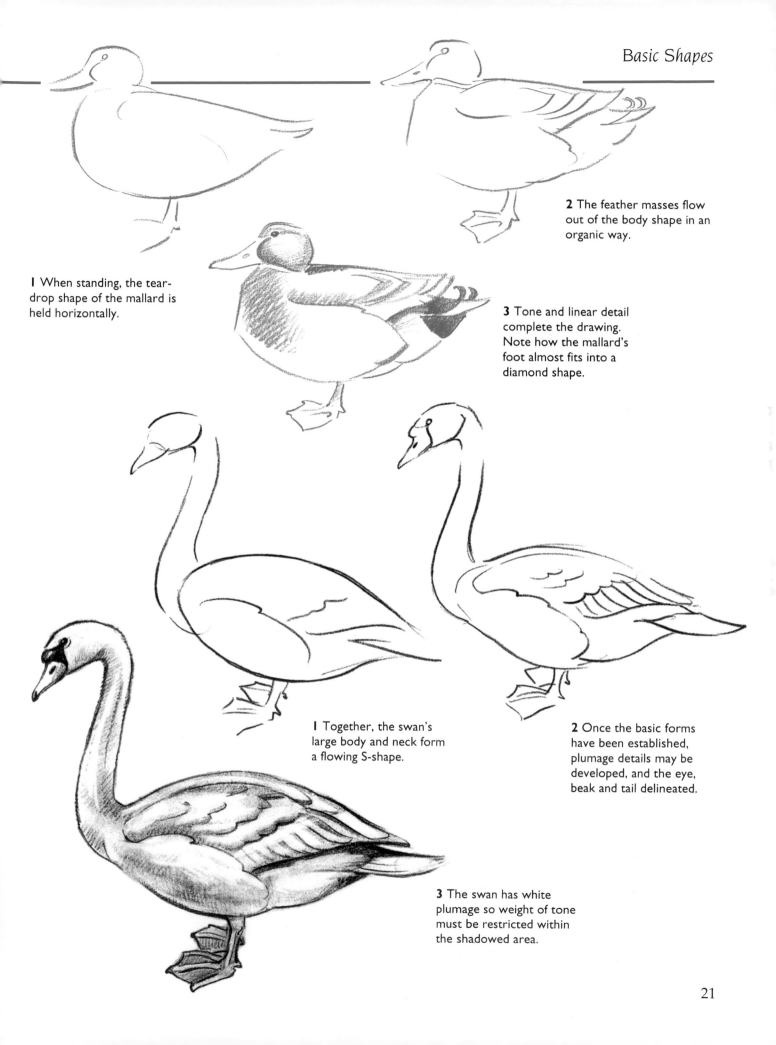

2 The feather masses flow out of the body shape in an organic way.

1 When standing, the teardrop shape of the mallard is held horizontally.

3 Tone and linear detail complete the drawing. Note how the mallard's foot almost fits into a diamond shape.

1 Together, the swan's large body and neck form a flowing S-shape.

2 Once the basic forms have been established, plumage details may be developed, and the eye, beak and tail delineated.

3 The swan has white plumage so weight of tone must be restricted within the shadowed area.

Cranes

The crane has been a favourite subject for the bird artist for centuries, and in the Far East it is associated with longevity and good fortune. It is a bird that strikes beautiful attitudes, forever mobile, but pausing occasionally to adopt a pose that will give you time to draw. It has a noble head, long neck and legs, with a fine brush of plumes to bring up the rear.

The crane's fluid shapes are perfectly complemented by the flow of watercolour brushwork. You could try a calligraphic approach, working from the wrist and elbow, keeping these loose and relaxed – and even holding the brush vertically in the manner of a Chinese artist. In the drawings here, I have imitated silk painting by using very strong colour on pre-dampened watercolour paper.

For the bird opposite, I began by practising rhythmic shapes on rough paper until I was sure of the forms. The feeding bird below presents shapes which are more circular. The technique of working into damp paper gives a tactile, feathery quality to the marks made by the brush.

1 I sketched in the circular frontal shapes in pencil first to guide my brush. I erased these pencil marks when the watercolour was dry.

2 I dampened the paper. Then, working quickly and confidently, I drew into it with strong colour.

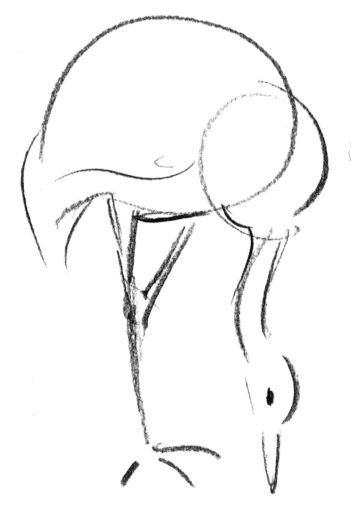

1 I searched for the basic shapes beforehand, drawing these on rough paper and stressing the rhythmic curves. I then sketched in the basic shapes on watercolour paper.

By adding spittle or ox-gall solution, obtainable in art shops, pigment will not spread out of control on the surface. The effect achieved can be full of mood, softness and depth.

2 I added the details of the neck markings, bill, crest, head, tail and feet.

3 I worked in carefully but rhythmically with a charged brush on damp paper. I waited for the paper to dry so that I could complete the neck with crisp line.

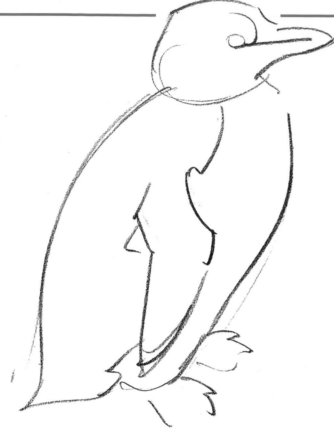

Penguins and puffins

These pages show the steps necessary to draw two sea birds – the penguin from the southern hemisphere and the puffin from the northern – which both dive to catch fish.

The penguin has lost its power of flight, and its flippers have now become wings for underwater 'flying'. It has strong feet on which it shuffles around. Its close plumage is best rendered in hatched pencil-work, which brings out the smooth contours.

The puffin also uses its wings underwater but, unlike the penguin, has retained its capacity for flight. On land, it has a comical rolling gait. In summer, its bill becomes enlarged.

3 I suggested the close feathering on its back, the bill features and the heavy feet. I took care to preserve the patchwork around the eye as this contributes to the penguin's essential expression.

1 I sketched in the basic shapes of this penguin. Its body is very apparent with legs shortened almost to nothing, and wings hanging separately.

2 I developed the contours with hatching strokes of a graphite stick.

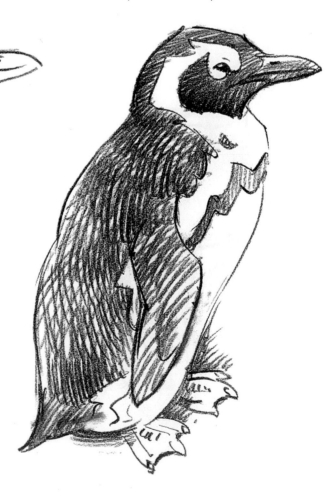

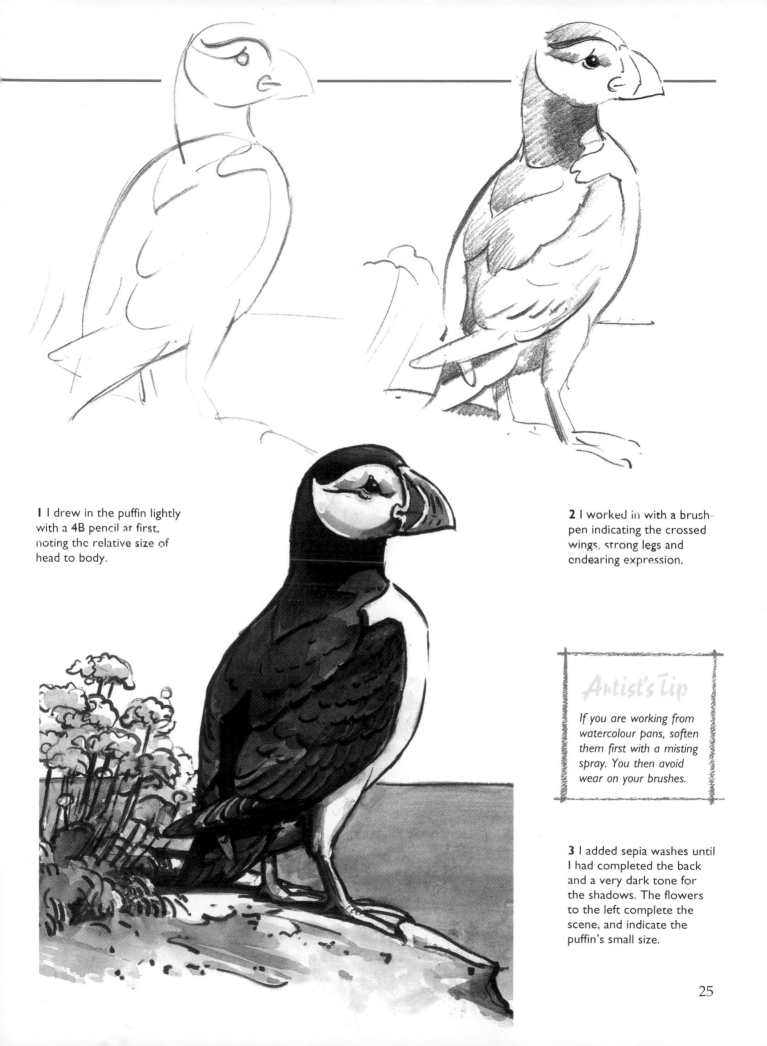

1 I drew in the puffin lightly with a 4B pencil at first, noting the relative size of head to body.

2 I worked in with a brush-pen indicating the crossed wings, strong legs and endearing expression.

3 I added sepia washes until I had completed the back and a very dark tone for the shadows. The flowers to the left complete the scene, and indicate the puffin's small size.

Structure and Form

Feather arrangement

Feathers are complicated things to draw but it helps to realize that they break up into clearly defined areas and masses. All birds are streamlined for flight and this means that the feathers must overlap from the front of the crown down the nape, the back and the upper tail coverts and over the tail. The head feathers organize themselves around the eye.

The wren, shown below, demonstrates how the feather masses fold around the basic body shape. The cormorant opposite shows exactly the same feather features as the wren, which is microscopic in comparison. The feathers fold over each other in the same way, much as shingles cover a roof, fitting snugly over each other. In flight, as the wing lifts up, all these feather areas loosen to let in air, and tighten up as the wing plunges downwards to gather it.

Terminology

It is useful to know a little of the terminology because it will help you to identify the plumage areas and physical features as you observe and draw birds. I have suggested here a minimum terminology which should provide for the needs of the bird-artist.

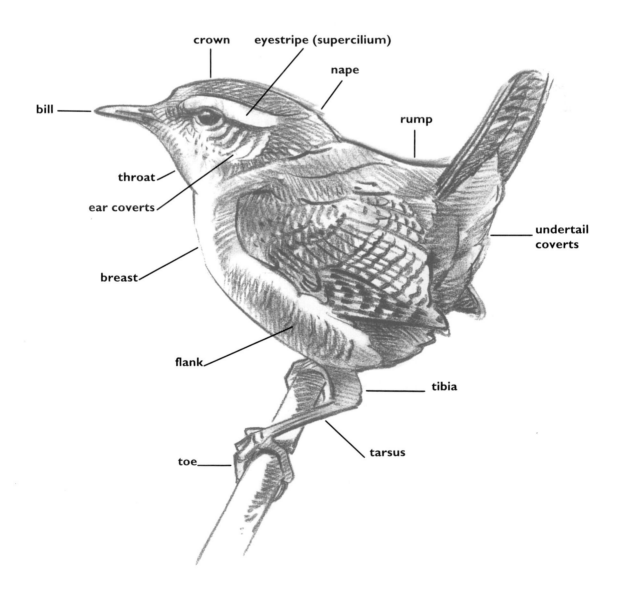

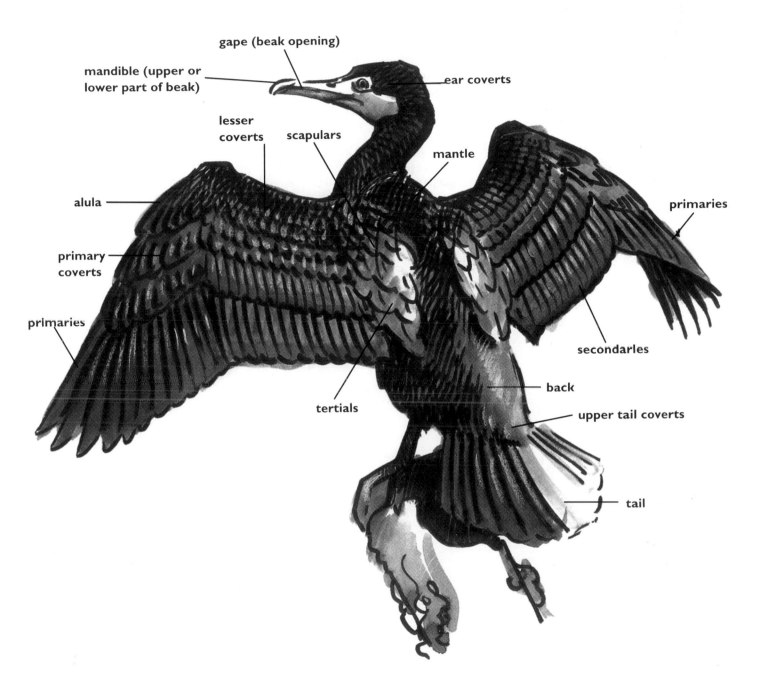

gape (beak opening)

mandible (upper or
lower part of beak)

ear coverts

lesser
coverts

scapulars

mantle

alula

primaries

primary
coverts

secondarles

primaries

back

tertials

upper tail coverts

tail

Legs, feet and wings

It may help to understand a bird's anatomy if you remember that the wings have developed from front limbs or arms, and the bird stands on its 'back' legs, much as a horse does when it rears up. The tarsus, the leg from the joint down, is in fact an extended foot, while the foot itself consists simply of the toes. The real knee is held closely to the body under the flank feathers and is rarely seen. The legs consist of three main bones which allow the leg to be folded.

The wings correspond to our shoulders, elbow and wrist, the 'hand' being the point from which the primary feathers sprout. The wings have the same tripartite structure as the legs allowing them to spread fully or compress into a zigzag to be folded and stowed away.

The falcon has large, dark eyes *(above)*. The bill, as in all birds, is part of the underlying skull structure.

In front-view the falcon's brow is wide *(above)*.

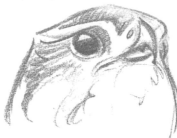

From below we see less of the falcon's crown, and more of the chin and the lower beak *(above)*.

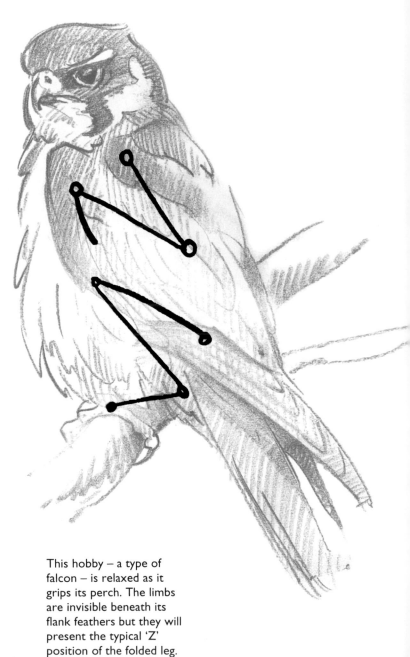

This hobby – a type of falcon – is relaxed as it grips its perch. The limbs are invisible beneath its flank feathers but they will present the typical 'Z' position of the folded leg.

This sparrowhawk is at ease but alert *(left)*. It is balanced on its centre of gravity at the knee. Both wings and legs are folded into a zigzag.

Wings stretch open in flight action and the legs extend fully as the sparrowhawk prepares to pounce on prey *(above)*.

Proportion and Perspective

Proportion – the sizes of different parts in relation to each other – is greatly influenced by perspective – the optical illusion that causes objects to appear smaller or narrower the further away they are. For example, in the front view of the hen pheasant below the body appears more shallow than it does in side view because perspective has condensed the form. This perspective effect is known as *foreshortening*. The bird's tail is similarly foreshortened.

Proportion and age
Another factor that has an influence on proportion is age. All young creatures, including birds, have a relatively larger head-to-body ratio than the adult birds.

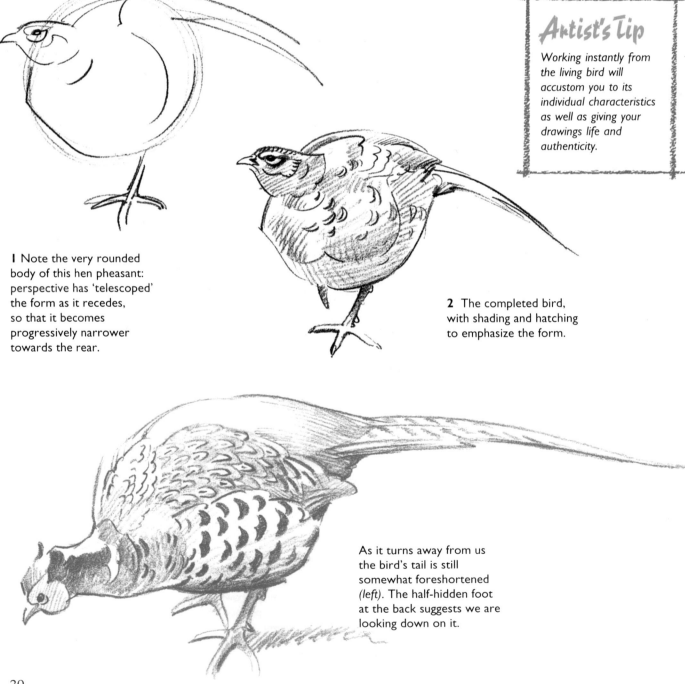

> ## Artist's Tip
>
> *Working instantly from the living bird will accustom you to its individual characteristics as well as giving your drawings life and authenticity.*

1 Note the very rounded body of this hen pheasant: perspective has 'telescoped' the form as it recedes, so that it becomes progressively narrower towards the rear.

2 The completed bird, with shading and hatching to emphasize the form.

As it turns away from us the bird's tail is still somewhat foreshortened *(left)*. The half-hidden foot at the back suggests we are looking down on it.

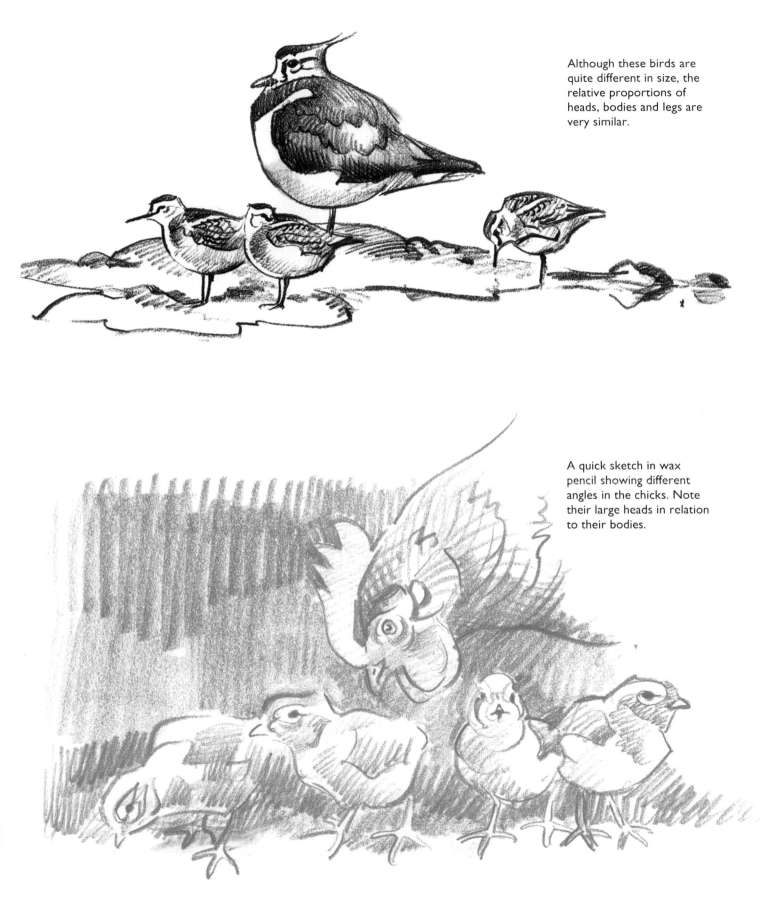

Although these birds are quite different in size, the relative proportions of heads, bodies and legs are very similar.

A quick sketch in wax pencil showing different angles in the chicks. Note their large heads in relation to their bodies.

Light and Shade

Shadows fall on objects as the light hitting them diminishes. Do not think of shadows as being solid, however: light reflected back from other surfaces tempers the density of shadow. You can see the effects of light and shade on the snow goose below. Both stages 2 and 3 show strong tonal contrast but, because the light is coming from different directions, shadow and reflected light fall differently in the two drawings.

Back-lighting

The Bewick's swan on the opposite page is lit from behind, showing how even a white bird can deepen in tone when seen against the light-source. The back-lighting creates a fringe of light tone around the head, even under the chin. Multi-coloured birds such as the male pheasant will appear dark against sunlight, but will show a fringe of light all around them.

Highlights

Whatever their colour or pattern, feathers are superb at catching the light. Glossy feathers will also have a highlight.

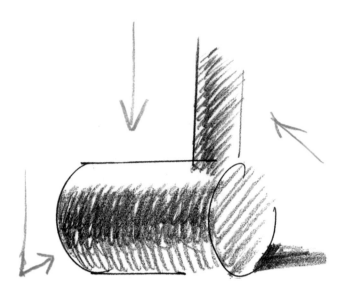

Light falling from above is often reflected back up onto the subject, as shown in this diagram of a bird's basic body shape *(above)*.

Tonal contrast can be greatest where light and shade meet – here, along the middle of the 'body' – creating a sense of solidity.

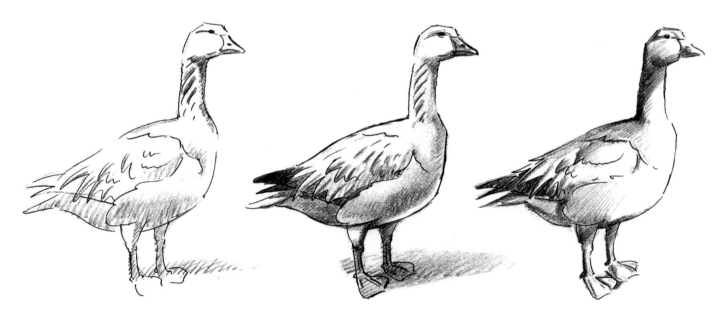

1 The outline was sketched in with a fine pen from a tracing. I began toning in the shadow with a pencil, which I could adjust until I got it right.

2 In this final version, light is coming from behind. Note the reflected light beneath the body. Each feather mass also has its own light and shade.

3 In this alternative version, light comes from one side resulting in simpler and stronger contrasts between areas of light and shade.

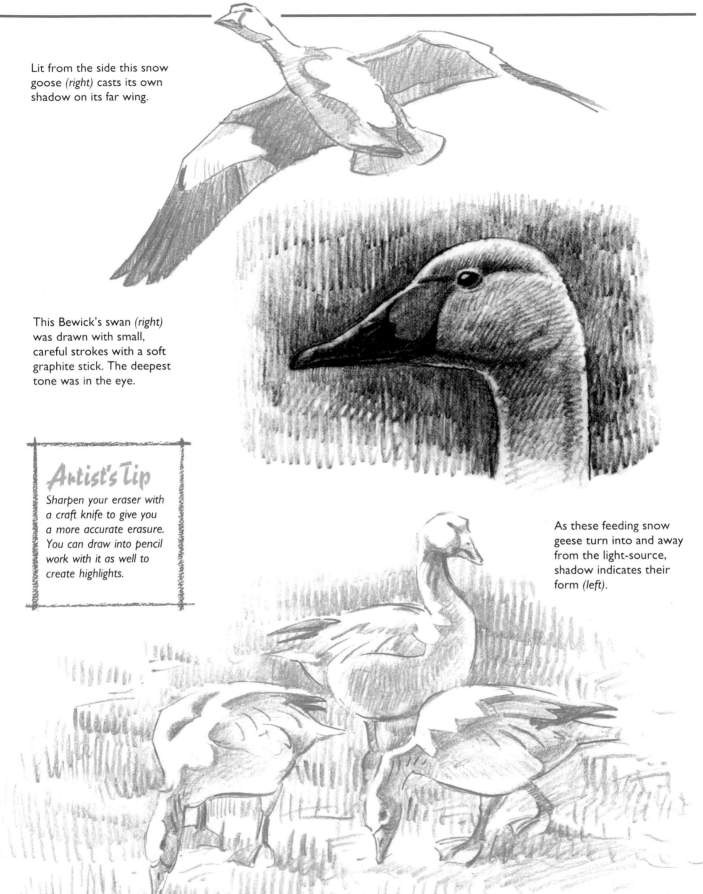

Lit from the side this snow goose *(right)* casts its own shadow on its far wing.

This Bewick's swan *(right)* was drawn with small, careful strokes with a soft graphite stick. The deepest tone was in the eye.

Artist's Tip

Sharpen your eraser with a craft knife to give you a more accurate erasure. You can draw into pencil work with it as well to create highlights.

As these feeding snow geese turn into and away from the light-source, shadow indicates their form *(left)*.

Looking at Detail

Eyes

Eyes are the most important feature in bird drawings. Their size, angle, shape and colour help to define the character of each species. The eyes of hunting birds are usually large. The gannet and parakeet shown here have smaller eyes, but no less sharp vision by day. Hawks and eagles have binocular vision whereby the eyes face forward to judge distance. The eyes of ducks, geese and swans are placed on the side of the head for all-round vision.

The eyes are surrounded by the orbital ring and then successive rings of feathering which blend back gradually into the ear coverts and the supercilium (eye-stripe).

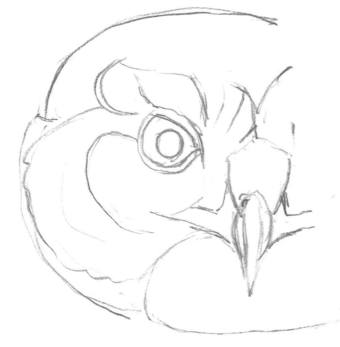

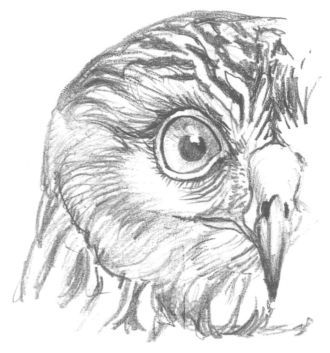

1 A preliminary drawing of the harrier, which is almost owl-like in its well-demarcated facial discs.

2 The artist has worked in with pencil to create the striations (bands) leading from the eye.

1 The artist has drawn in the eyelid and orbital ring first, and marked out the highlight over the pupil.

2 To complete the drawing, he has deepened the eye and stressed the shadow of the eyelid on the iris.

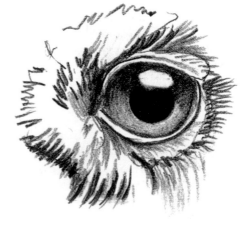

The gannet's eye, like that of many fish-eating birds, is connected by skin to the beak *(below)*.

The unfeathered areas around the gape (beak opening) of the gannet and heron *(right* and *above)* show how intimately eye and bill are connected.

1 The parrot's hooked beak is similar to that of the falcon, but its small eye and domed crown give it a distinctive difference.

2 The artist has worked with overlapping strokes in pencil to suggest the web of feathers around the parrot's head.

Beaks

Beaks and bills – such as the hook of the peregrine falcon, the great secateurs of the toucan, the spoonbill of the duck and the tweezers of the avocet – are all horny extensions of the skull and help to define a bird's character, giving it its own particular expression.

Placing the nostrils correctly is important. For example, those of the peregrine are protected by the cere, a yellow covering of skin above the beak. The duck's nostrils are placed high on the bill so that it can dabble and breathe at the same time. The avocet's nostril is a groove along the top mandible.

I The peregrine's hook encompasses the eye and curves naturally into the skull. The cere above it divides the forehead and, with the down-turn of the gape, makes the bird look as if it is frowning.

2 The artist has used sensitive strokes of a sharpened pencil to hatch in individual facial feathers and to add shading that defines the forms.

I & 2 The toucan has more bill than head, giving the bird a genial, almost comical appearance. The characterful shape allowed the artist the freedom to sweep a great curve from tip to nape.

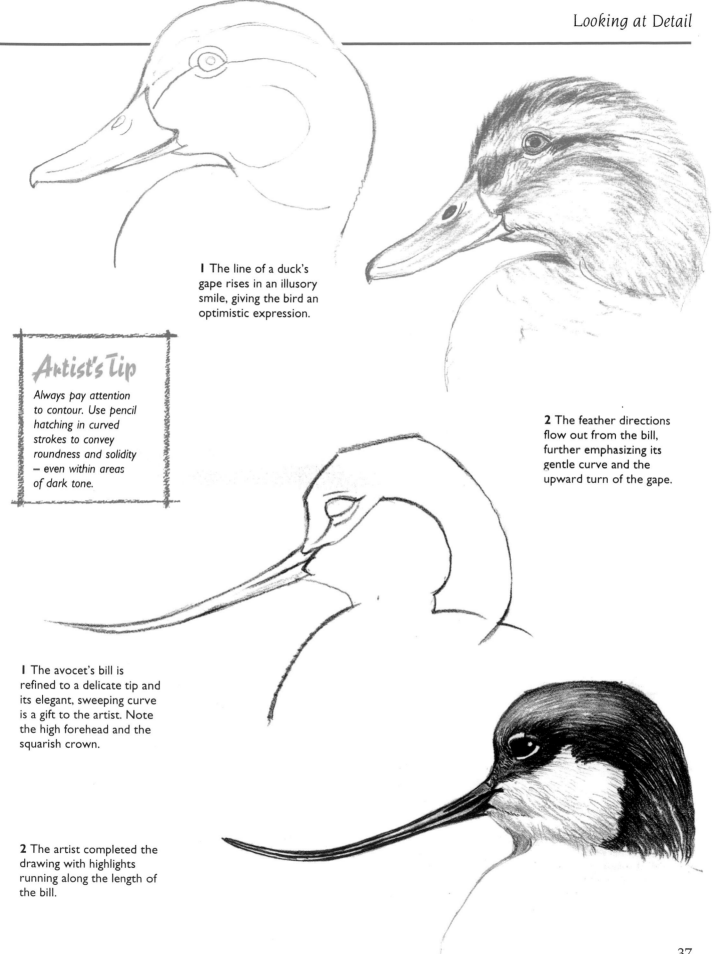

1 The line of a duck's gape rises in an illusory smile, giving the bird an optimistic expression.

Artist's Tip

Always pay attention to contour. Use pencil hatching in curved strokes to convey roundness and solidity – even within areas of dark tone.

2 The feather directions flow out from the bill, further emphasizing its gentle curve and the upward turn of the gape.

1 The avocet's bill is refined to a delicate tip and its elegant, sweeping curve is a gift to the artist. Note the high forehead and the squarish crown.

2 The artist completed the drawing with highlights running along the length of the bill.

Feet

Three toes forward and one behind is the usual structure for a bird's foot. Woodpeckers, however, show two at the front and two at the back. The easiest way of rendering a twig-gripping bird's foot is to suggest a small fist and work into it with two lines.

Feather masses

Each feather or feather mass has muscles attached, making them capable of individual movement. If a bird is cold it will raise its feathers to insulate itself. Feathers can also be raised in display or alarm, as in, for example, the cockatoo and the bustard opposite. The fan-like construction of birds' tails is also interesting to look at. The middle feather is uppermost and the rest slide out when spread from beneath each other.

1 With its long, curved talons, the peregrine's foot is designed for gripping prey. The artist has plotted out a claw position with parallel lines for toes, linking the middle toe to the shin.

2 He then added details, such as highlights on claws, and scales on the toes.

1 Ducks' webbed feet are a diamond shape projecting from the leg, with the middle toe running laterally. The rear toe is no longer used.

2 Details of the toenails, scales and webbing were added to the rough outline.

1 The nuthatch uses its claws to grip bark. Its front toes are an extension of the leg; note the long hind toe and nail.

2 The artist completed this study of a nuthatch's feet by working into the preliminary sketch with a sharp, 3B propelling pencil.

The cockatoo's crest flows back on its domed forehead and over the eye *(above)*.

When erect, the cockatoo's crest fans from above the beak and completely changes the shape of the head *(above)*.

A large bird, the bustard *(left)* has a well-developed beard which it can raise to puff out its neck. When raised, the plumes flow back along the bill and sweep down the neck *(above)*.

2 The tail feathers were completed by showing their herringbone formation *(below)*.

I & 2 The swallow's tail fans out, the streamers on either side accentuating the triangular shape, and assisting the bird's fast, darting flight.

I The artist first plotted out the lines of the underlapping feathers of this tail *(right)*.

39

Texture and Pattern

Birds excel in the arts of colourful display and its antithesis in camouflage. To impress their mates, some male birds, such as the pheasant and the peacock, have carried this to dazzling lengths. Other males make use of individual feather masses for decorative effect. The cockerel's sickle tail feathers are in fact its upper tail coverts, not the tail itself, which supports them. The same is true of a peacock's backdrop of eyes; its actual tail is a disappointing affair concealed behind.

Clever camouflage

The hens of these species are, by contrast, cryptically camouflaged, mottled and textured to blend with their background. Other species, such as the nightjar – a miracle of delicate design – do the same, vanishing by day against the forest floor. The chequered patterns of the jay, a brightly coloured woodland bird, break up its shape in the mottled patches of sunlit leaves in what is known as 'disruptive camouflage'.

The red kite demonstrates how feather edging reveals the feather patterns as they fold like tiles on a roof around the bird's body. Each feather possesses its own individual pattern and mark, and the artist has brought these out in a range of dots, dashes and strokes, each varying in tone.

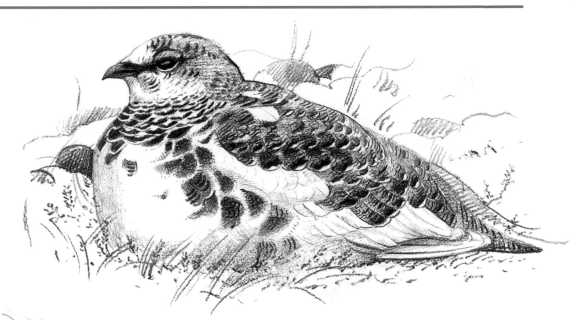

The ptarmigan *(right)* is half-mottled and half-white in spring when the snow has not yet melted fully. It relies on this tonal contrast to break up its shape in the landscape.

A detail of a pheasant's scapular feathers *(below)* showing tonal subtleties as they overlap each other. In this case, camouflage has become decoration.

Artist's Tip

A gentle and noiseless approach to the birds will help you in your observation of them. Avoid rattles and rustling items in your kit-bag.

The nightjar *(below)* flies by night and relies on its wonderful textured camouflage to conceal it by day.

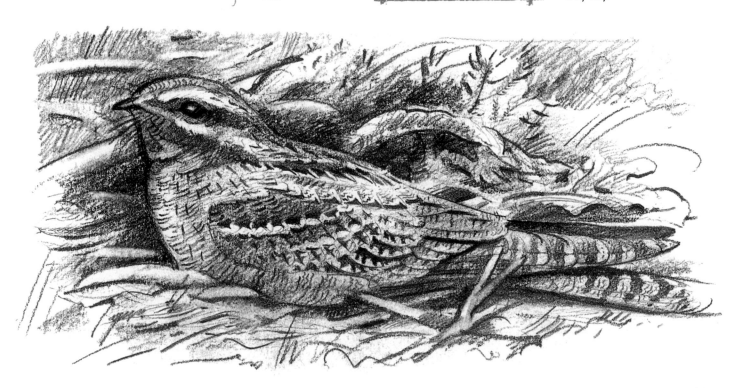

Behaviour and Movement

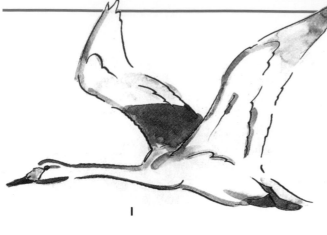

1

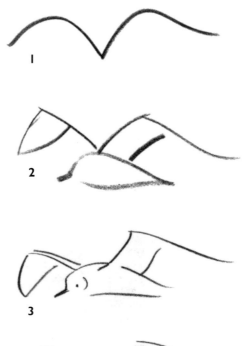

2

Drawing birds in flight presents one of the greatest challenges. Birds fly in characteristic ways according to their role in nature.

Styles of flight
Easiest to observe and draw are the gliders whose wings remain relatively still. Gulls, for instance, will follow ferry boats for long periods and hardly move their wings at all. Herons have a slow, lumbering flight which gives you time to take note. Birds of prey soar with outstretched wings on thermals.

To understand regular, beating flight, it helps to know something of the mechanics, as illustrated in the 'stills' of the swan here.

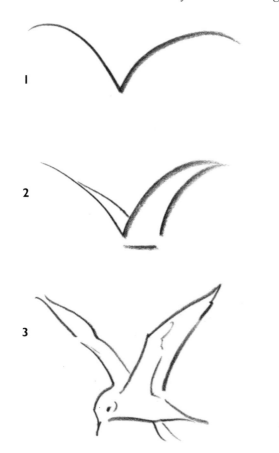

1

2

3

1 I began this gull *(left)* with a childish V-shape and proceeded to elaborate.

2 More of the nearside wing is visible on the up-beat, so it is wider.

3 I continued developing the shapes, adding darker pencil work as I went.

1 Again I began simply with an M-shape halfway up the wing-beat of this gull *(right)*.

2 In perspective, the wings present an alternate thick-thin pattern.

3 & 4 With some refinement, the drawing begins to resemble a flying gull.

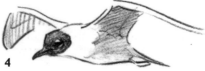

1

2

3

4

1 The wild swan *(far left)* is caught at the peak of its up-beat, the tips ready to flick back to drive it along.

2 Next the wings begin their descent, the flight feathers now packed tight together to force air down.

3 As the wings descend, the primary feathers are bent upwards, separating slightly to assist air flow at the tips.

4 The primaries bend up more as the wings reach the bottom of the beat.

5 The up-beat begins from here and the feathers loosen to allow air to enter from above.

6 At this dramatic point, the wings are at their height ready to flick up to begin the next down-beat.

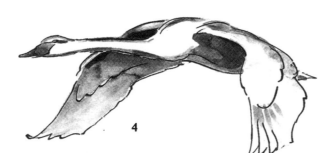

Artist's Tip

A cross-section of a bird's wing reveals a slight concavity underneath and a swelling upper surface. This gives it more lift. Contour shading and hatching can suggest this.

3

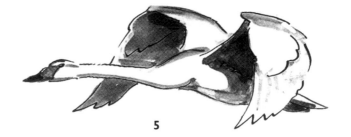

4

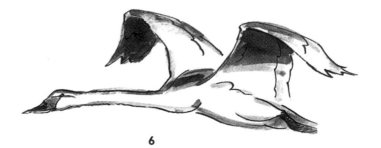

5

6

1 & 2 When the wings are held level and viewed side-on, you see them in foreshortened form *(above)*. You can see even less of the far wing.

Effortless flight

Each bird's flight pattern and rhythm depend on the length and width of its wings. The heron has broad, blunt wings and can travel long distances without great effort. The chough delights in playing in the clifftop breezes. It, too, has broad wings but also long primary feathers that give it 'fingertip' flying control. Each one is adjustable to any air current available. It can also close its wings and dive down vertical cliff faces.

Underwater fliers

The puffin has smaller wings in relation to its plump body, and beats them more rapidly to maintain flight. This blur of wing movement can be suggested by a few pencil strokes. Paradoxically the bird becomes a superb glider underwater as it flies after fish to catch them in the depths. The penguin has adapted completely to flying underwater, its beauty and elegance under the waves belying its clumsiness on land.

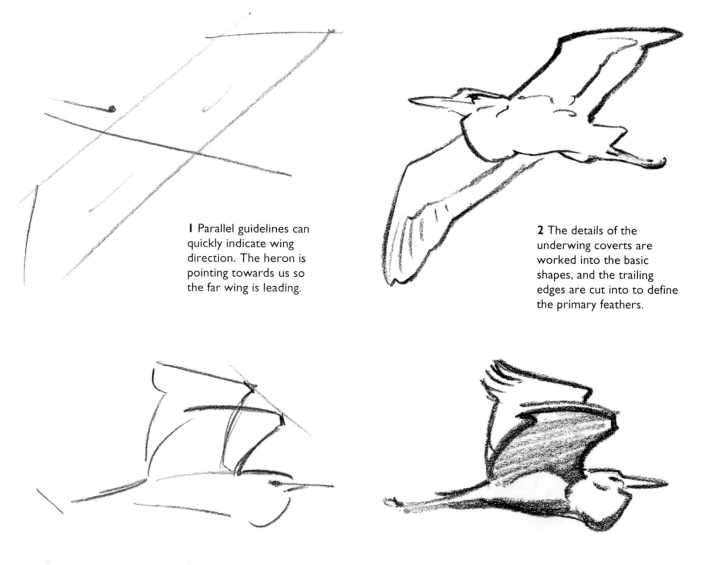

1 Parallel guidelines can quickly indicate wing direction. The heron is pointing towards us so the far wing is leading.

2 The details of the underwing coverts are worked into the basic shapes, and the trailing edges are cut into to define the primary feathers.

1 As it curves towards us, the near wing is foreshortened by the effect of perspective. The body is a simple tapered shape.

2 The visible primary feathers on the far wing are developed in greater detail. Note how the bird's neck is coiled out of the way.

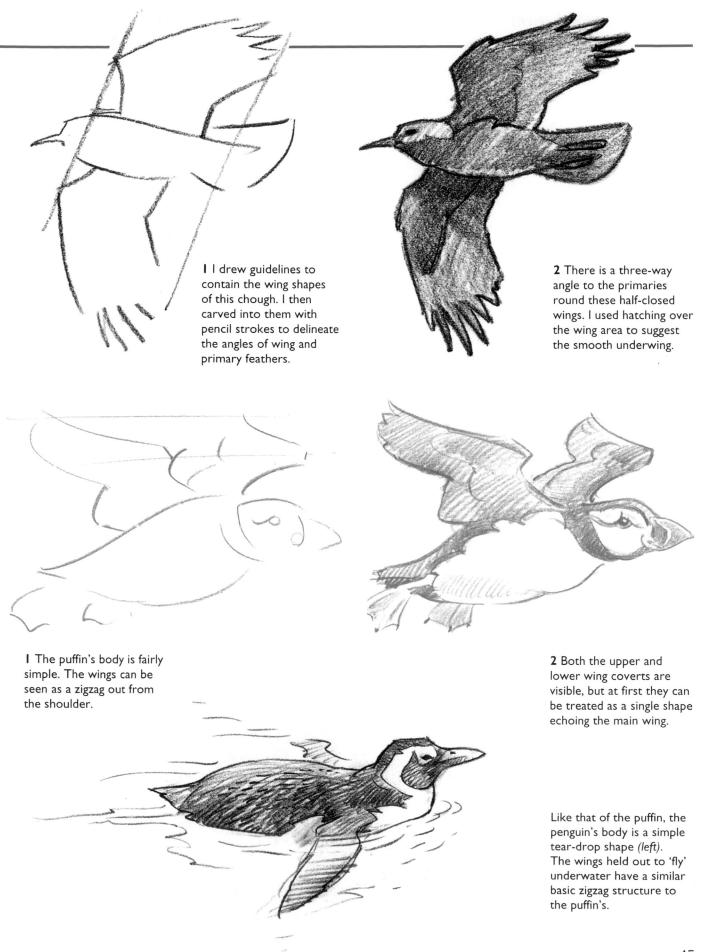

1 I drew guidelines to contain the wing shapes of this chough. I then carved into them with pencil strokes to delineate the angles of wing and primary feathers.

2 There is a three-way angle to the primaries round these half-closed wings. I used hatching over the wing area to suggest the smooth underwing.

1 The puffin's body is fairly simple. The wings can be seen as a zigzag out from the shoulder.

2 Both the upper and lower wing coverts are visible, but at first they can be treated as a single shape echoing the main wing.

Like that of the puffin, the penguin's body is a simple tear-drop shape *(left)*. The wings held out to 'fly' underwater have a similar basic zigzag structure to the puffin's.

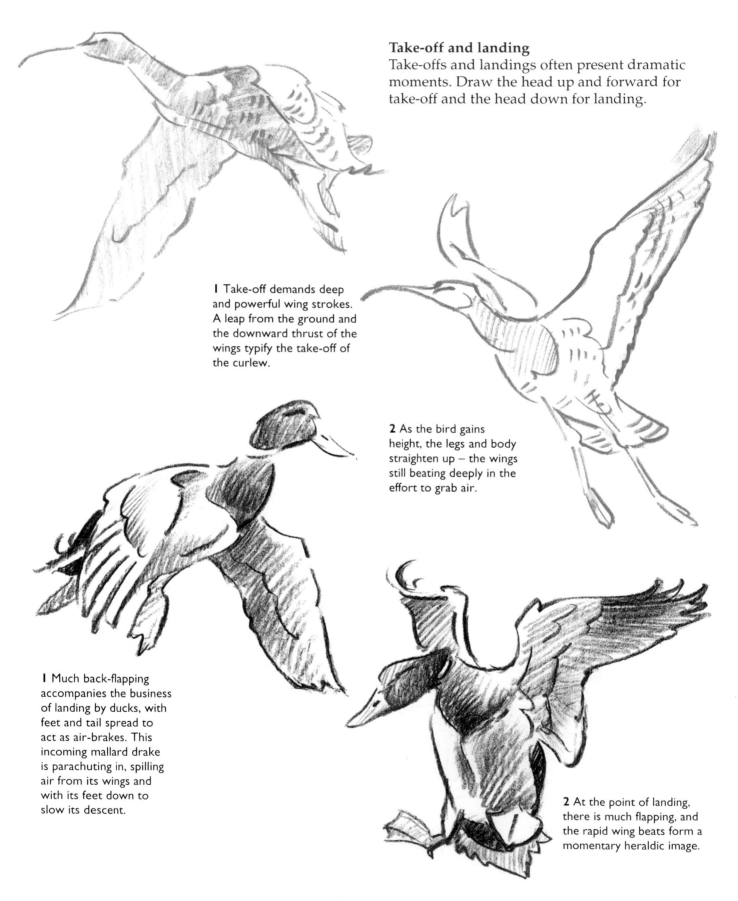

Take-off and landing
Take-offs and landings often present dramatic moments. Draw the head up and forward for take-off and the head down for landing.

1 Take-off demands deep and powerful wing strokes. A leap from the ground and the downward thrust of the wings typify the take-off of the curlew.

2 As the bird gains height, the legs and body straighten up – the wings still beating deeply in the effort to grab air.

1 Much back-flapping accompanies the business of landing by ducks, with feet and tail spread to act as air-brakes. This incoming mallard drake is parachuting in, spilling air from its wings and with its feet down to slow its descent.

2 At the point of landing, there is much flapping, and the rapid wing beats form a momentary heraldic image.

Walking

The extraordinary length of the stilt's legs makes it an ideal subject for studying positions in the walking bird. Your study of bird structure will remind you that the bird's legs are actually its rear limbs. The knee is hidden under the flank feathers but there is more flexibility there than is immediately apparent.

When the bird is running or wading, the leg positions can be more extreme. As a general rule, in order to progress, one leg is drawn back and lifted as the bird's neck and head contracts ready to push forward again. As the leg projects forward, the head straightens to help the bird's momentum as it shifts its weight forward to step down.

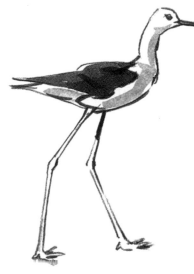

The walking sequence of a stilt, beginning with a standard pose showing the 'backwards' joint.

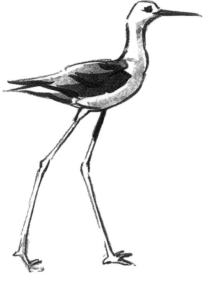

The rear leg is raised ready to lift from the knee which is hidden beneath the flank feathers.

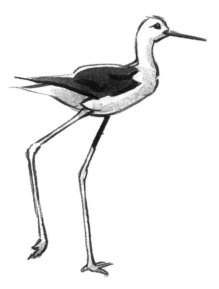

The leg is now lifted off the ground and begins to fold, ready to take a step forward.

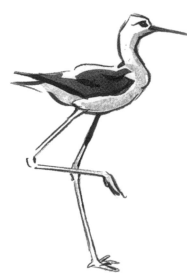

The leg is folded, the toes project ready to feel their way forward.

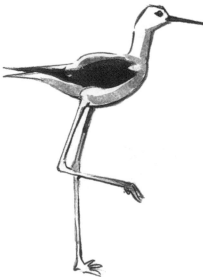

The body weight shifts forward as the leg is lowered.

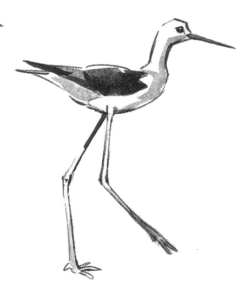

The bird prepares for 'touchdown' with the leading toes.

Everyday activities

The way in which different birds perform everyday tasks, such as feeding, sleeping and preening, depends to a great extent on their physical appearance. For example, the parrot's long tail which steers it through thick jungle must be preened in a different way from the curlew's short one, but both must keep their claws and faces clean.

Watching birds in relaxed postures can be very enjoyable. The curlew, for instance, is able to balance on one leg and rub its head and long bill by extending the other leg. Other moments may be more dynamic, such as the displaying sandwich tern shrieking harshly or the heron stretching its neck to fish.

In this pen-and-wash drawing (above), the parrot grips the branches with one foot and cleans the other foot with its bill.

The gannet (left) adds nesting material to its home while the youngster sits alongside.

A curlew rubs its head (above): the artist has severely formalized the feather masses in order to capture the bird's action.

Head back, the shoveler stretches its wing and foot simultaneously (left). Feather markings and colour patches can assist you in defining the forms involved.

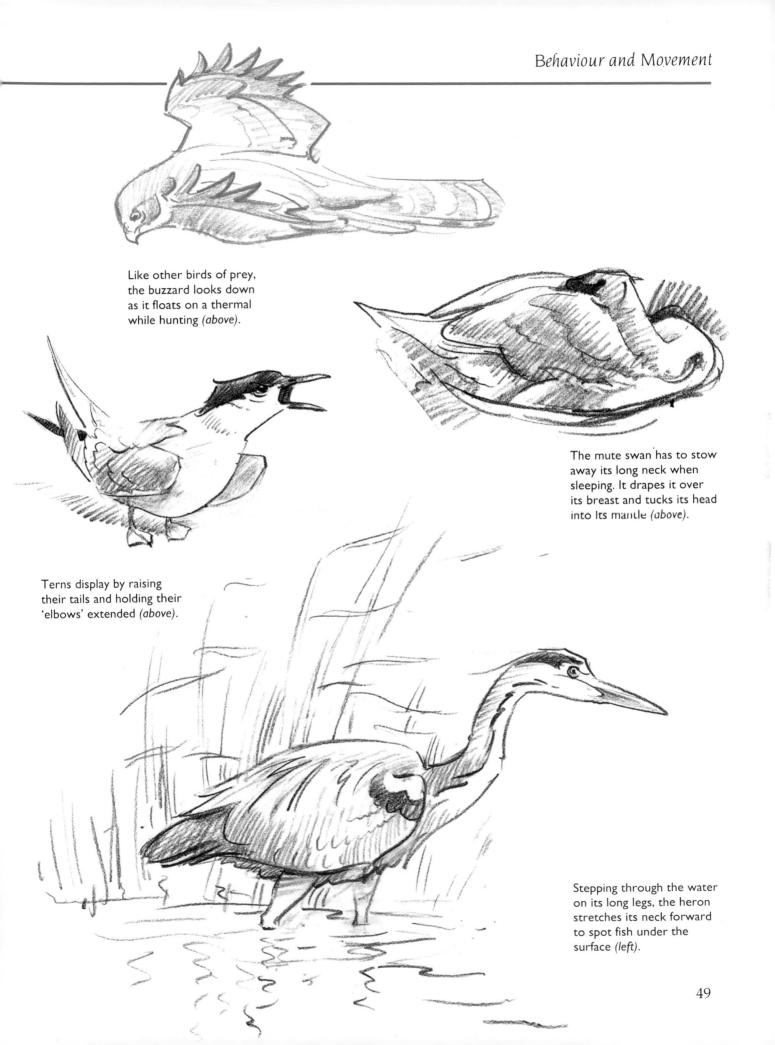

Like other birds of prey, the buzzard looks down as it floats on a thermal while hunting (above).

The mute swan has to stow away its long neck when sleeping. It drapes it over its breast and tucks its head into its mantle (above).

Terns display by raising their tails and holding their 'elbows' extended (above).

Stepping through the water on its long legs, the heron stretches its neck forward to spot fish under the surface (left).

49

Sketching

Sketching is the life-blood of bird-drawing. A few bold marks can capture movement, shape and behaviour in a manner that a more detailed drawing cannot. Throw caution to the winds when you are sketching and put down any squiggle or mark when some exciting event is happening. Don't be self-conscious about this: the primary purpose of sketches is to aid your memory and to provide information for more elaborate work later. Your first line may not capture the complete bird but will be enough to help remember the whole pose. Sometimes the bird will return to its original pose and you can add some more to your sketch.

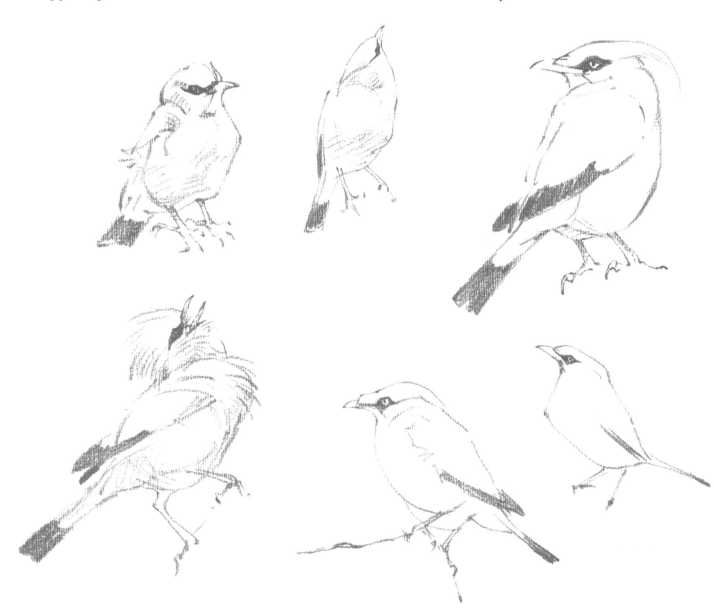

The Rothschild's mynah in various poses, rendered in a few well-chosen lines with conté pencil. *Clockwise from top left:* in relaxed state, the bird rests back on its feet. The artist has noted its full breast and squarish tail. When the bird looks up and away, the crown becomes prominent. The black 'mask' around the eye is an important guide to head position. When the bird sings, it throws its head back and puffs out its throat feathers. The bird returns to ease in these two final side views which capture its essential shapes.

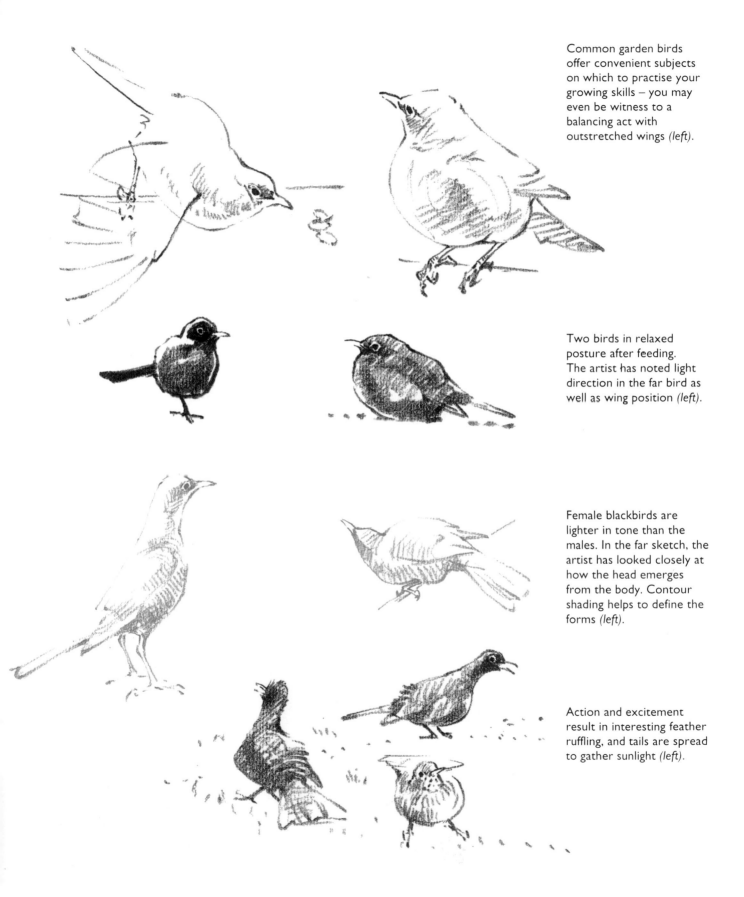

Common garden birds offer convenient subjects on which to practise your growing skills – you may even be witness to a balancing act with outstretched wings *(left)*.

Two birds in relaxed posture after feeding. The artist has noted light direction in the far bird as well as wing position *(left)*.

Female blackbirds are lighter in tone than the males. In the far sketch, the artist has looked closely at how the head emerges from the body. Contour shading helps to define the forms *(left)*.

Action and excitement result in interesting feather ruffling, and tails are spread to gather sunlight *(left)*.

The kittiwake is a delightful gull. Here, the artist has used conté pencil to capture its character and its flight action *(above* and *right).*

Building up a record

Sketching allows you to build up a library of information, as well as recording many happy memories of places visited and birds seen. Fleeting glimpses of birds often mean that a sketch must be put down hurriedly, which is why it is so useful to have knowledge of the bird beforehand. On this page, there is a rapid rendition of a hobby falcon's facial pattern seen through a telescope; sketches of the kittiwake's flight pattern and a preening gannet; and the strange shapes of displaying black grouse. The mixed group of birds on the right were set down to keep me familiar with their various shapes.

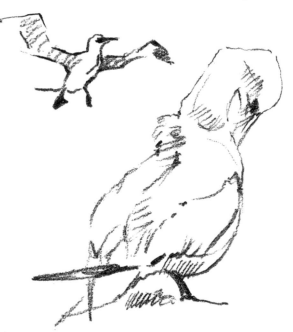

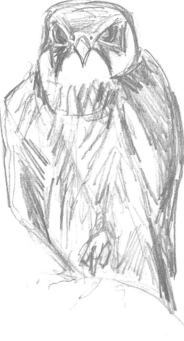

The artist has looked at the sharp features of the hobby falcon's head in a frontal view *(above* and *right).* Distance often simplifies patterns.

A quick response to a preening gannet *(above).* Many years of practice and observation of the bird have gone into this sketch.

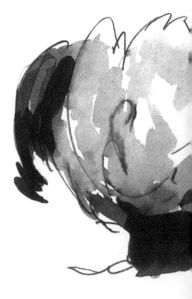

52

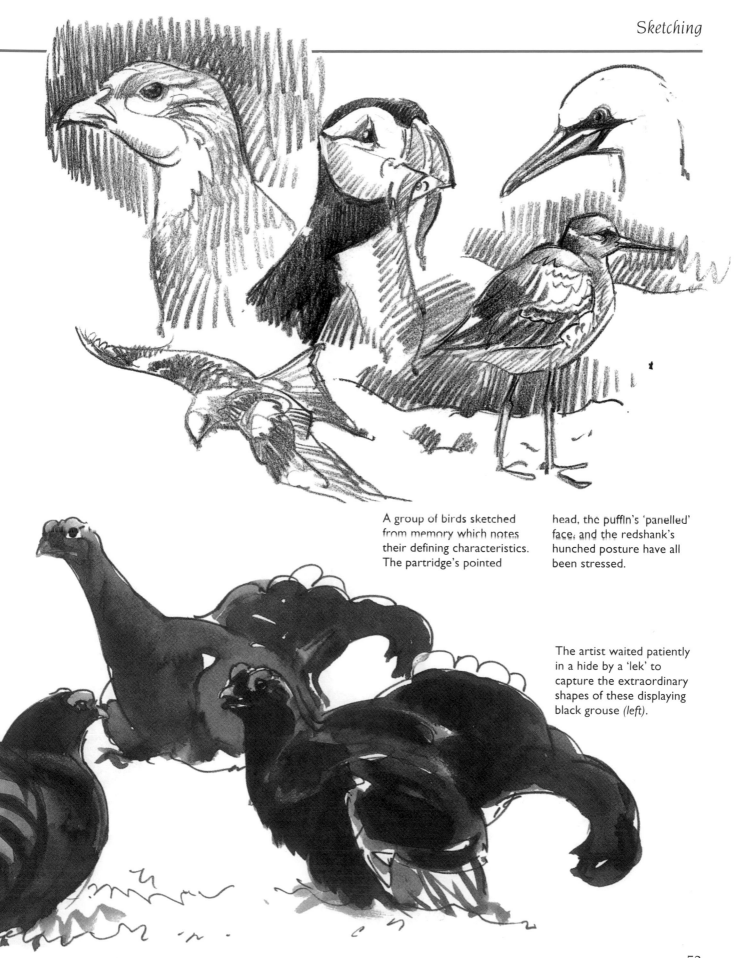

A group of birds sketched from memory which notes their defining characteristics. The partridge's pointed head, the puffin's 'panelled' face, and the redshank's hunched posture have all been stressed.

The artist waited patiently in a hide by a 'lek' to capture the extraordinary shapes of these displaying black grouse *(left)*.

Fleeting moments

Put down marks as soon as possible while the scene is before you and is still fresh in your memory. Even the most striking images can fade quickly in the memory if they are not noted.

The angular divisions caused by the facial discs and closed eyelids make an invaluable feature on a sleeping owl *(left)*.

The eagle opens its mouth to give voice, suddenly revealing the shape of its lower mandible *(right)*. The fierce brow is noticeable.

Use your sketches to record information for later use *(below)*. What does a plover look like from behind? Can you see a puffin's wings from the front view? Note such details down while you have the chance.

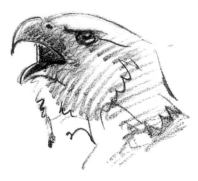

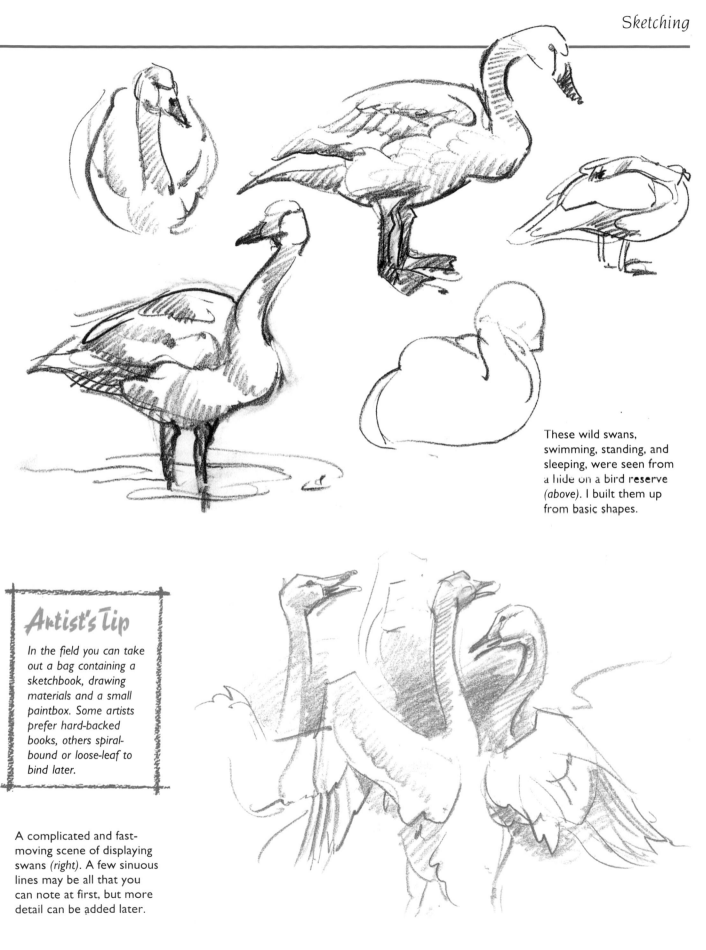

These wild swans, swimming, standing, and sleeping, were seen from a hide on a bird reserve *(above)*. I built them up from basic shapes.

Artist's Tip

In the field you can take out a bag containing a sketchbook, drawing materials and a small paintbox. Some artists prefer hard-backed books, others spiral-bound or loose-leaf to bind later.

A complicated and fast-moving scene of displaying swans *(right)*. A few sinuous lines may be all that you can note at first, but more detail can be added later.

Framing and Composition

Creating a composition can be seen as the ultimate goal of picture-making, where your studies, sketches and background information can all come together into a large work. These hints on organizing the elements in your picture may help you to express what you want to say in the most effective way.

Before you settle on a final composition, do several small sketches to try out different arrangements, as I did for the barn owl on the opposite page. One tip to remember is that it's best not to place your subjects in the middle of the page as this looks too predictable; an asymmetrical arrangement is more interesting.

Getting the balance right

As you exploit the possibilities in your preliminary sketches, you will discover how important it is to know where your picture begins and ends. This is the meaning of 'framing'. You can reduce or enlarge the background area of the picture by cutting it down or by expanding the borders. Investigate picture shapes other than the standard ones, too, such as panoramas and vertical shapes.

I used charcoal on a large piece of paper for these red-legged partridges amongst the foliage. Some birds overlap each other in a tight visual group, while the roaming chicks lead the eye out of the frame.

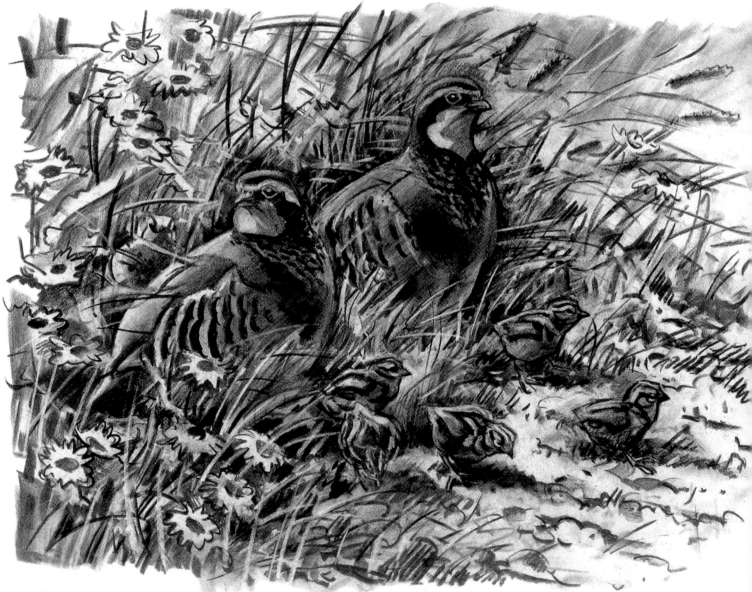

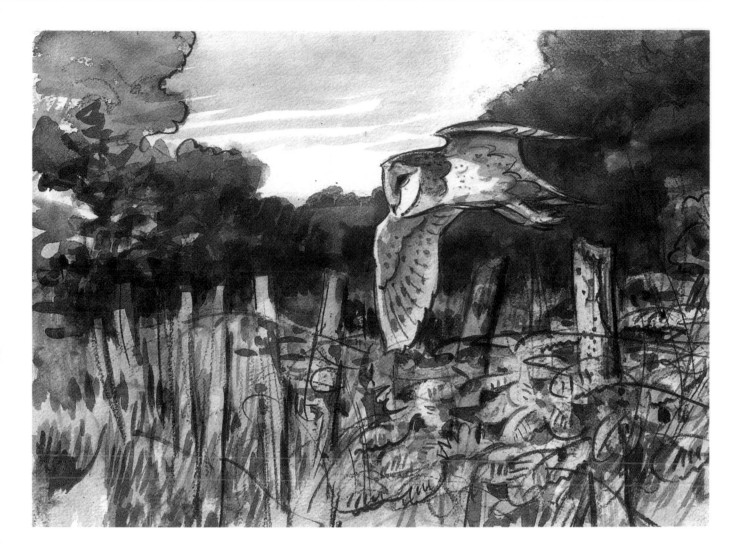

This owl was painted in pencil, pen and wash *(above)*. I positioned it to one side so that it has potential space in which to fly forward. Neither the fence posts nor the brambles compete with its free movement. The dark trees on the skyline pick out the bird but rise to the left to sustain the feeling of flight.

Do lots of little sketches like this *(left)* when you are exploring composition. You can gradually enlarge and develop what appear to be the most promising ones.

In Setting

Drawing birds becomes much more satisfying when you extend your interest to the world they inhabit and to which they are adapted. Often it requires only the slightest suggestion of a setting to convey something of a bird's way of life. An angular charcoal line can suggest the rock on which a pair of shags can be found by the sea, for example, as in the drawing below right. It also suggests the space around them. Notice how the shadow cast by the bird on the left links it to the rock.

Feeding birds

Goldfinches love teazle heads for their tasty seeds and are often to be seen perching and feeding on them, as illustrated to the left. The plant provides a visually exciting design as well. Such drawings are an exercise in scale: here the seed-head is as big as the chequered bird and indicates its small size.

Nesting birds

Drawing birds on the nest is to be avoided as a rule – disturbance can cause the bird to desert. However, the grebe family opposite was nesting on the river and I sketched them from the bridge which spanned it. They seemed unconcerned by passing traffic and made the perfect models. I arranged the willow leaves to frame the group. The circular ripples spreading out from the chick suggest the water surface.

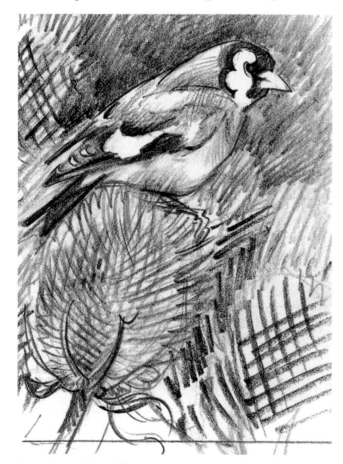

I used a graphite stick and worked with vigorous small strokes to suggest the cross-hatching on the seed-heads *(above)*.

Charcoal pencil seemed the right medium to capture these angular shags perched on the cliff *(right)*.

I blended this grebe's dark plumage into the dark tone behind it. This enabled me to leave the foliage untouched so that it could stand out.

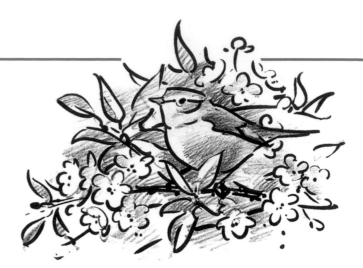

Habitat and weather

Each species is adapted to a particular habitat. The warbler snaps up insects amongst the leaves; the lapwing feeds on shores and pastures.

The time of day can be suggested by lighting and by the imaginative use of background detail. Weather conditions can be conveyed by the type of marks used. Urgent strokes of charcoal or pencil can portray rough weather, for example, while diagonal strokes can suggest wind direction.

The flowers around this warbler suggest that it is a summer visitor *(above)*. I created bold outlines with a brush-pen and used pencil softly for tonal work.

This lapwing *(left)* is depicted amongst the buttercups where its chicks may be hiding. Breaking up the form of the bird with the foreground grasses helps to integrate it with its habitat.

I drew this branch in my garden and noted the birds that used it at different times of day – wood pigeons in the evening and a blackbird in the morning *(far left* and *below)*.

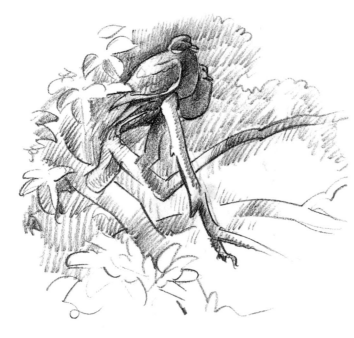

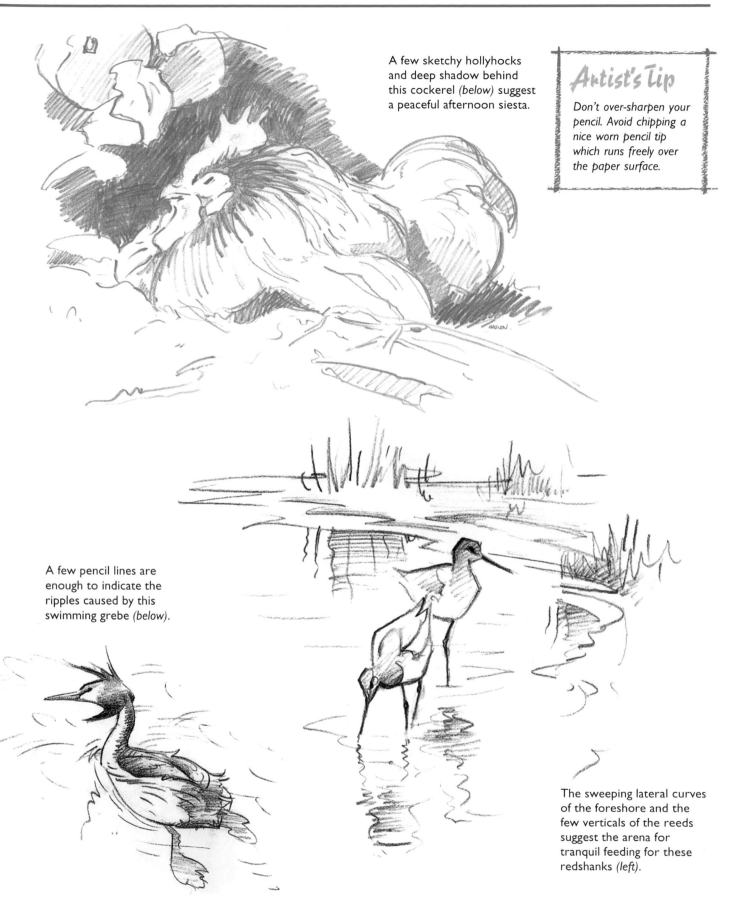

A few sketchy hollyhocks and deep shadow behind this cockerel *(below)* suggest a peaceful afternoon siesta.

Artist's Tip

Don't over-sharpen your pencil. Avoid chipping a nice worn pencil tip which runs freely over the paper surface.

A few pencil lines are enough to indicate the ripples caused by this swimming grebe *(below)*.

The sweeping lateral curves of the foreshore and the few verticals of the reeds suggest the arena for tranquil feeding for these redshanks *(left)*.

Working from Photos

Artists of bird-life will work from any available material to deepen their fund of knowledge. In photographs, whether from books or magazines, there is a vast store of information. Photographs enable you to study details of feather, of attitude, and effects of light and shade at your leisure. I prefer to use my own photographs and often carry a camera. If you are snap-happy, never forget to sketch the birds on the spot as well.

The liveliest approach to combining your photographs and sketches is to plot your ideas loosely and roughly on layout paper. Use any materials – pen, pencil, felt-tip – which are to hand to develop them. Trace off your first efforts until you are satisfied and then transfer the image to thicker paper.

Capturing movement

Wildlife programmes and videos can also be a rich source of ideas. Video footage can be 'paused' to give you more time to sketch, and can help you to understand such movements as flight, which are too quick for the naked eye.

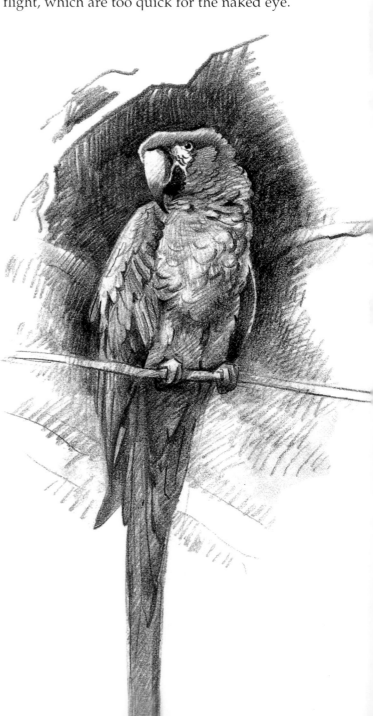

These birds were friendly enough, but I still used a telephoto lens to take the picture so that I could keep my distance *(above)*.

I used a soft pencil to develop my drawing from the photograph, and to investigate the bird's feathering *(right)*.

I substituted a natural environment for the artificial one in the photograph in my final drawing, done with pencil and wash on smooth watercolour paper.

Even if you are working from a photograph, it helps to do 'practice' sketches of your subjects to familiarize yourself with their forms *(left* and *right)*.

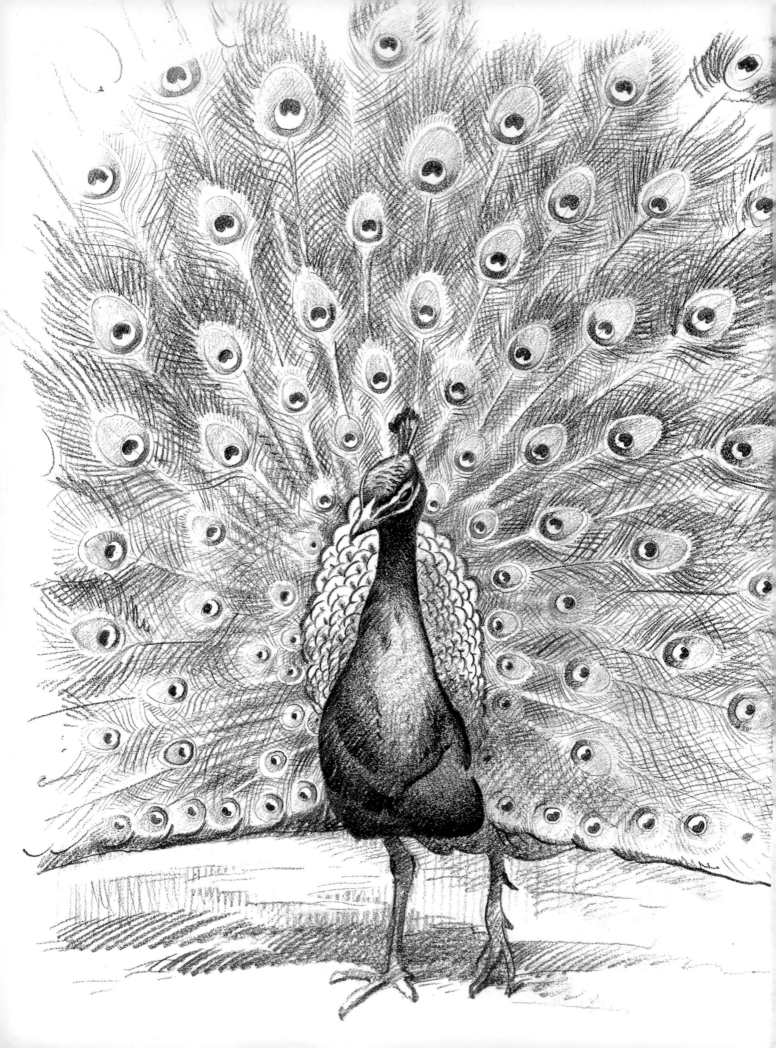